From the Heart

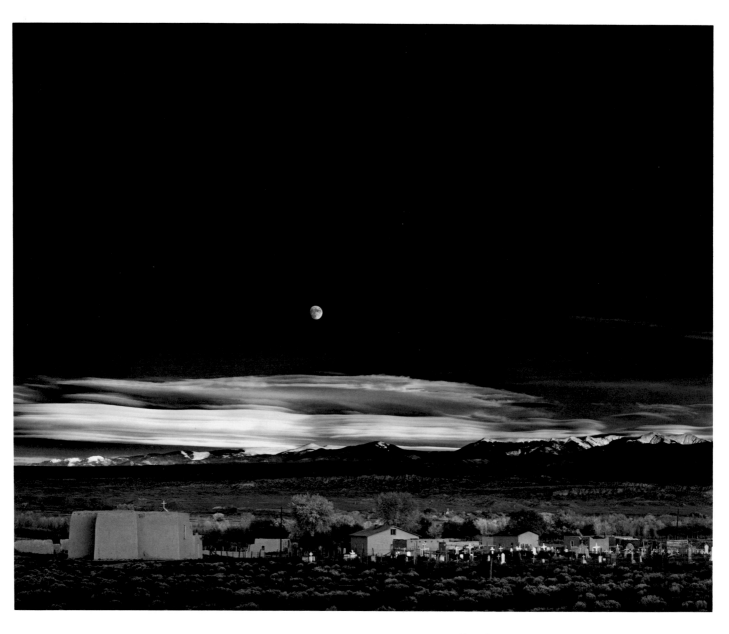

Moonrise, Hernandez,
New Mexico, 1941

"All art is the expression of one and the same thing—the relation of the spirit of man to the spirit of other men and to the world."

Ansel Adams
American, 1902–1984

From the Heart

The Power of Photography—A Collector's Choice

By Adam D. Weinberg

Preface by Mark Haworth-Booth
Essay by Marianne Wiggins
Biographies of Photographers by Peggy Roalf

Art Museum of South Texas, Corpus Christi

Aperture

Library of Congress Catalog Card Number: 97-75178
Hardcover ISBN: 0-89381-775-9
Paperback: ISBN: 0-89381-809-7

Cover photograph: Edward Weston, *Portrait of Tina Modotti*, Glendale, 1921, copyright © 1981 Center for Creative Photography, Arizona Board of Regents.
Back cover photograph: Jacques-Henri Lartigue, *Three Men on Four Wheels*, 1910, copyright © Ministère de la Culture, France/A.A.J.H.L.

Art Director: Wendy Byrne
Designer: Angela Voulangas
Color Photography: Jerry L. Thompson
Printed and bound by Marigros Industrie Grafiche SpA, Turin, Italy
Duotone separations by Robert Hennessey

Aperture Foundation publishes a periodical, books, and portfolios of fine photography to communicate with serious photographers and creative people everywhere. A complete catalog is available upon request.
Address: 20 East 23rd Street, New York, NY 10010.
Phone: (212) 598-4205. Fax: (212) 598-4015.

The staff at Aperture for *From the Heart* is:
Michael E. Hoffman, *Executive Director*
Lois Brown, *Editor*
Stevan A. Baron, *Production Director*
Elizabeth Franzen, *Managing Editor*
Helen Marra, *Production Manager*

Aperture Foundation books are distributed internationally through:
CANADA: General Publishing,
30 Lesmill Road, Don Mills, Ontario, M3B 2T6.
Fax: (416) 445-5991.
UNITED KINGDOM, SCANDANAVIA AND CONTINENTAL EUROPE: Robert Hale, Ltd., Clerkenwell House, 45-47 Clerkenwell Green, London EC1R OHT.
Fax: 171-490-4958.
NETHERLANDS: Nilsson & Lamm, BV,
Pampuslaan 212-214, P.O. Box 195, 1382 JS Weesp.
Fax: 31-294-415054.

For international magazine subscription orders for the periodical *Aperture*, contact Aperture International Subscription Service, P.O. Box 14, Harold Hill, Romford, RM3 8EQ, England.
Fax: 1-708-372-046. One year: U. S. $50.00.
Price subject to change.
To subscribe to the periodical *Aperture* in the U.S. write Aperture, P.O. Box 3000, Denville, NJ 07834.
Phone: 1-800-783-4903. One year: $40.00.

First edition 10 9 8 7 6 5 4 3 2 1

contents

The Collector's View

Mark Haworth-Booth

It is still a thrill to find photographs elegantly installed in fine art galleries. We think of this as a new phenomenon, only a generation old. Indeed, it was twenty-five years ago when Sondra Gilman discovered the intense pleasures afforded by photography and acquired her first photograph, an image by Eugène Atget. It makes her shudder even today as she recalls how much she found herself paying for the frail rectangle imprinted with a breath of Paris. She shudders again when she realizes how low the cost proved to be compared to later prices. At that time she not only began the fine collection we celebrate here, but also played a significant role in initiating the most splendid of all corporate collections of photography, that of the Gilman Paper Company in New York. Now Sondra Gilman is showing her own collection for the first time, offering a new generation the chance to experience the intense contact with visual things that she herself experienced at the outset of her life as a collector.

It has been remarked that Noah was the first collector—"Adam gave names to the animals, but it fell to Noah to collect them"—and that Noah "perhaps alone of all collectors, achieved the complete set."[1] However, this striking thought immediately gives rise to a second one: some of the animals Noah collected were spectacular collectors themselves. The magpie and jackdaw are well known in this respect, with their love of shining things. Charles Darwin wrote about an extraordinary bird, *Calodera maculata*, "which makes an elegant vaulted passage of twigs for playing in, and which collects near the spot, land and seashells, bones and the feathers of birds, especially brightly colored ones."[2] What is this—installation art, practiced by Australian birds, in the 1830s? Questions of collecting and display remain mysterious, thought-provoking, and not entirely rational. Perhaps this is particularly true of collecting photographs.

My own career as a collector of photographs also began in the early 1970s—in a museum. I have had the pleasure of meeting many of the key individuals from the golden age of photographic collecting—the academics, auctioneers, collectors, consultants, curators, and dealers. I have known collectors who cannot bear to be parted from their latest acquisition, to the extent that they drive on long journeys with the precious love-object in the trunk of the car—just as Sir George Beaumont drove the rutted roads of early nineteenth-century England with a prized painting by Claude in his coach. (The painting is now in the National Gallery in London.) Some collectors candidly admit that their avocation is more an addiction, comparable with a tobacco or opium habit. Others acknowledge all that and insist that collecting is a way of understanding the world, a kind of metaphysics. Some collectors limit themselves to one aspect of photography—flowers, hands, the nude, portraiture, real estate, and many other categories—and adhere to arbitrary criteria with obsessive inflexibility. The late Sam Wagstaff declared that once you buy a picture knowing full well that there is no more room on your walls to hang it, at that moment you become a collector.[3]

The enchantment of collecting photographs has a long, if fitful, history. We are just beginning to discern some of its most vivid moments and individuals. One of the earliest glimpses into the culture of collecting photographs takes us to Paris in 1851. The world's first photographic society, La Société Héliographique, had the idea of assembling annual albums of photographs. Each album would demonstrate the artistic and technical progress of photography. Collectors could acquire "photographic rarities, some portraits, photographs of celebrated monuments, landscapes and so on. . . ." The society's albums would become a "true Museum, a historical Museum, which would one day be precious and necessarily consulted by those who wished to review the beginnings and the progress of photography."[4] Connoisseurs were encouraged to buy fine photographs to place alongside the fine prints and drawings in their collections: after all, many of the earliest photographers came to the medium from painting or printmaking. If one

day the society should be wound up, then the albums would be offered to the print room of the Bibliothèque Nationale. In this way they would receive "*une consécration définitive*"—a final and permanent endorsement of their worth. The private museum would join the public one. As it happens, the collection of La Société Française de Photographie has recently joined that of the Bibliothèque Nationale, and a circle envisaged long ago has been completed.

So were there really collectors in the 1850s? Certainly. So far, the best documented are English, beginning with Queen Victoria and Prince Albert. Each year they visited the annual exhibition of the Photographic Society of London, of which they were patrons. The photographs they chose for their private collection were assembled into a series of albums of superb quality, preserved today in the Royal Archives at Windsor Castle.[5]

Among the early collectors we can identify today are the extraordinary bibliophile, Sir Thomas Phillips, whose photographic collection was acquired in the early 1960s by the late Harrison D. Horblit. For Phillips, collecting was not merely a habit or a mania but a pathological condition. His rich photographic collection has been elegantly described by Eugenia Parry Janis and is now in the Houghton Library at Harvard University.[6] Another identifiable early connoisseur-collector is the poet and mesmerist Chauncy Hare Townshend (1798–1868). He was an intimate of Charles Dickens, who dedicated *Great Expectations* to him. He could have bought the photographic treasures he owned from a variety of dealers in London and Paris. Townshend's ardent and obsessive observation of fine prints was lampooned by Wilkie Collins in the Victorian bestseller *The Woman in White* (1860). Townshend was the model for the notorious collector "Mr Fairlie" in Collins's novel. I hope Collins was exaggerating in this passage: "His valet was standing before him, holding up for inspection a heavy volume of etchings, as long and as broad as my office writing-desk . . . while his master composedly turned over the etchings, and brought their hidden beauties to light with the aid of a magnifying glass." Perhaps Townshend was a monster like "Fairlie," and yet the novel also suggests the delicate visual delights among which (from everything we know about him) he lived.

Townshend bequeathed his superb photographs—by Roger Fenton, Gustave Le Gray, Camille Silvy and others—to a new institution, the South Kensington Museum in London (renamed as the Victoria and Albert Museum in 1899). Henry Cole, the founding director of this new museum of the fine and applied arts, is the first remarkable curator-collector of photographs. He visited the Photographic Society's annual exhibition in 1856 and bought photographs of the nude, still lifes, and landscapes—thus beginning what is probably the earliest museum collection of the art of photography. In 1858 Cole staged the first international exhibition of photography in any museum. It was opened by Queen Victoria and Prince Albert. In 1865 Cole sat for the pioneering photographer Julia Margaret Cameron. He bought eighty of her photographs and exhibited them in the museum, touring them nationally as well. Cameron wrote to Cole about her large-scale, radically interpreted and heroic heads: "They will electrify you and startle the world." The photographs that electrified Cole have gone on electrifying collectors ever since.[7]

By Mrs. Cameron's time photography was in use—simultaneously—by artists across a complete range of practices from visionary to industrial. Between them, photographers were portraying almost everything almost everywhere. This fact was recognized by another early article about collecting photographs. The idea had become very different from 1851. "Collections of Photographs," in *The Photographic World* in 1872, advanced the notion of the collection as reproducing the whole world and its photographable history, "a comprehensive representation of the manners, life, and characteristics of the various nations of the world."[8] In a few decades photography moved from being a thrilling new way of understanding the world to becoming the accepted way of describing everything: it is something like the rise of the computer from the preserve of boffins, to the gizmo of an elite, to the standard-issue communications medium.

This progression had serious consequences for photographic collecting. The early enthusiasm ebbed away, partly because photography became universal. The development of process engraving harnessed photography at last to the

printed page and the volume production of journalism. Photographic collecting became, despite some notable exceptions, an activity of photographers themselves. The leader of American art photography, Alfred Stieglitz, not only exhorted, exhibited, and published his colleagues, but also collected them. As Harry H. Lunn Jr. has written: "In 1933, tiring of the burden of storing his personal collection of Photo-Secessionist masters in the face of nearly a complete lack of public and critical interest, [Stieglitz] telephoned the print department of the Metropolitan Museum of Art and demanded that a truck be sent to remove the collection to the museum, on pains of his trashing it if the response there was negative. Fortunately, the truck was sent, and this hoard is now one of the central pillars of the Met collection. . . ."[9] Actually, as Malcolm Daniels has recently pointed out, Stieglitz had been actively cultivated by curators at the Metropolitan.[10] However, although in general art museums like the Met and the Victoria and Albert did sporadically collect outstanding specimens of earlier photography, they generally shied away from the avant-garde. There were some haunting exceptions to this rule. For example, Curt Glaser became director of the Kunstbibliothek in Berlin in 1924. He exhibited and acquired important works from the greatest avant-garde photographers—Laszlo Moholy-Nagy, Albert Renger-Patzsch, Max Burchartz, Florence Henri, and others. The exhibitions, acquisitions, and Glaser's career came abruptly to an end in 1933, however, because he was a Jew.[11] Because of the indifference of curators and collectors, other photographers became— like Stieglitz—important stewards of the medium's history. Man Ray's Eugène Atget photographs are now in the George Eastman House in Rochester, New York; the Atget archive preserved by Berenice Abbott was acquired by the Museum of Modern Art (MOMA), New York, and Frederick Sommer's Atgets are now in the J. Paul Getty Museum in Malibu, California. Similarly, the first paperback book on the history of photography in English was written by a photographer—Lucia Moholy—in 1939.[12] In 1946 the photographer Helmut Gernsheim began, with his wife Alison, to collect historical photographs and the materials for the history they published in 1956.[13]

The modern market for fine photographs began in 1970, according to Harry Lunn in the article already cited. The timing of the new and widespread recognition of photography as a fascinating and collectible medium is important: it surely reflects the displacement of photography by television, during the 1960s, as the major carrier of mass information in Western societies. The creativity of photographic artists had been hidden by the overwhelming power of the medium as a whole.[14] In 1971, Lunn opened his gallery in Georgetown, Washington, D.C., selling Ansel Adams photographs at $150 a print, and Sotheby's held their first auction of photographs in London. Sotheby's New York followed in 1975.[15] This is the significance of the Sondra Gilman Collection. She is one of a group of pioneering contemporary collectors whose passion for photography has thrown the unique properties of the medium into high relief. Her choices shared here have explored, identified, refined, and celebrated the medium she found herself confronting in 1972. The museologist Susan M. Pearce writes of the collecting process as "a form of fiction, through which imaginative constructions can be expressed. And, like the use of language in fiction, objects in a collection can be used in a range of poetics."[16] The collection of Sondra Gilman, presented for the first time in this publication, offers us a poetic interpretation of the photographic medium and the world.

Marianne Wiggins

Being human is contagious.

Consider this:

You are somewhere spacious, some place of massive space, perhaps enclosed like an airport or open like a park. You are *in public*, yours is not the only figure in the landscape, there are other people with you in this picture, nearby, not too close, walking past you, talking. How many people doesn't matter. More than ten. Maybe hundreds. All are strangers to you. What you're doing in this place doesn't matter either. You decide. Maybe it's a supermarket and you're shopping. Maybe it's an intersection and you're on your way to work. Maybe you have a date in fifteen minutes and you're late. The sun is beating on your head. You're in a hurry. Or you're sitting on the aisle in a row of seats waiting for whatever is supposed to start to start.

Suddenly a toddler pitches forward to the ground.

Or two lovers lock in amorous embrace.

Or that guy in the corner pulls a fist on the person shouting at him.

And before you know what's happening your eyes meet the eyes of a total stranger and the two of you exchange *a look* and instantly you know you're feeling the same thing. That *look*— that jolt of recognition—where does it come from? Does it leave a trace? Does it have a shape? What is its color? Where does it go when it doesn't exist? Where can we find it? Where does it wait when it's not in the space that's between us?

As I write this, I am sitting in my garden in London, 3,000 miles from my friend Sondra Gilman's brownstone in New York, where I first encountered many of the photographs in this book. That was on a moody autumn evening four years ago, a light rain making the Upper East Side streets near Sondra's house shine like darkened windows. But it's early summer now. My senses register the season not because of temperature (we suffered a hailstorm and a June ground frost last night), nor because the sun's a radiating spotlight on the world this morning (it's *not*: we haven't seen the sun all week),

but because the air right now is thick with the distinctive sweet aroma of a privet hedge full of sex—in pollinating bloom. On a branch inside the hedge beside me I can see a downy fledgling, like a furry egg, edgy, shaking the leaves around it, drawing my attention to its first impending jump into the air and its genetic destiny. Above me, over the branches of the peeling sycamores, another form of aerial migration: a transatlantic British Airways jet descending to its nest at Heathrow. A lawn mower whirrs. Last month's lilacs have turned rusty; rosebuds, like unwrapped candies on the tongue, are about to burst. The lowering sky is blasted white, not the sky-as-sky-should-be, not a *real* sky, the sky of blue illusion, vast and high and wide as the first sky pictured in this book in Ansel Adams' photograph. But you can see the kind of sky this is— the kind of morning I'm describing—can't you? You can see it in your mind, piece a picture from my words, create an image of it somewhere in your imagination, an image only you can see. Not the one above me, not my London sky—but never mind, *you get the picture*. In less than the proverbial thousand words we made a picture happen, you and I. We made it in your mind. Now do this: punch a hole in your imagined sky, make it open like a waking eye like this donut hole of crystal blue that's just opened up above me in these clouds, like a curtain parting, like a window or an air shaft or a transparent envelope onto another sky, a sky behind the sky, no more or less "real" than the one in front of it.

And that's what photography *is*—the sky behind the sky, a transparent envelope—while, at the same time, that's what photography *isn't*. I'm not playing with words (well, I *am*, really: that's what writing is: a mind engaged in a playtime of meaning)—even the most renowned photographers suffer a verbal equivalent of the soft-focus when it comes to defining what photography really *is*. Alfred Stieglitz himself, one of American photography's founding fathers, one

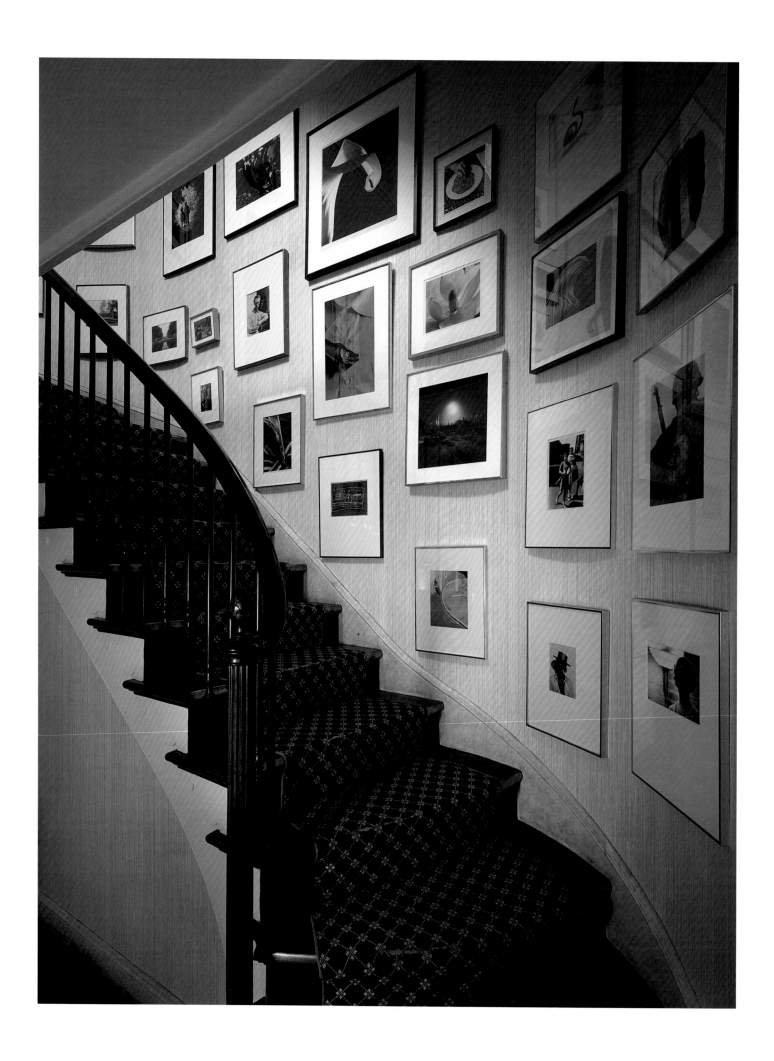

of the framers of its constitution, so to speak, spent his later years softening many of his former black-and-white convictions about what a photograph is and does. In the early '20s, he began a series of photographs called "Equivalents," all of which, like the one of clouds (or of the sky-behind-the-sky) on page 25, were meant to enforce his belief that "those who see it will relive an equivalent of what has been expressed."

But *an equivalent*? What the heck is that? An equivalent of what? To what? The *what*lessness of photography's definition as an art form seems to be sewn into its seams—it is almost always talked about as if it has no other material existence than as a metaphor—and yet it does exist, it is an object in and of itself, not just a thing *about* a thing, but Thing, itself: fragile, tactile, vulnerable to fire, damage, stormy weather, like the rest of us. But just to give you an idea of how hard it is to say what makes a photograph into a work of art, here's a list of titles of books written either by or about the photographers themselves:

Nature's Pencil William Fox Talbot
The Flame of Recognition Edward Weston
Mirrors, Messages &
 Manifestations Minor White
I'll Be Your Mirror Nan Goldin
Distortions André Kertész
The Eloquent Light Ansel Adams
Shadow of Light Bill Brandt
Shadow and Substance W. Eugene Smith
The Life and Times of
 Shadow Catcher Edward S. Curtis
Still Time Sally Mann

According to Edward Weston, photography should be "seeing plus."

For Francis Brugière it's "some sort of section of the soul of the artist that gets detached."

For Robert Frank it's "what's invisible to others."

For Robert Adams, "an alchemy."

For my friend Sondra Gilman, the collector of all of the above-quoted photographers, it is a "feeling in the stomach."

Are all these (presumably) sane people talking about photography?

Or are they talking about . . . *love*?

． ． ．

She *has* to love it, that's the only thing she says. I press her for criteria—there must be some One Thing all the photographs in her collection share?

She shakes her head.

"You tell me if you can find it," she advises.

But after two days studying—and I mean really studying—the collection in her home, I confess to her that if there is a One Thing, a single motivating criterion, that either I can't see it, or the word for it eludes me.

Sondra shakes her head again.

"What did I say?" she says, "I just have to love it."

． ． ．

It's mystifying.

Daunting, too, when you've been asked (as, obviously, I have been) to weave a narrative from that invisible thread, the thread that travels through each one of these photographs and ends securely tied to my friend's heart. It's not that I can't *always* see what she sees in them—I can't see what she sees *ever*. Even in the ones that I admit I love, because each person brings to art his or her own life, his or her own history, eye, experience. This much I've learned from years of writing novels. People come up to me at readings and say, "I loved your book." (Fortunately for me, the ones who hate it stay away.) I thank them. Then ask, "Just out of curiosity, *what* did you love about it?"

You should see their faces.

Blank.

Not that I've caught them lying (surely not), but I've caught them with no way to say exactly why or how words printed on a page could possibly elicit their emotions. Of course words, even printed ones, *do* elicit strong emotions—anyone who reads knows the mind cannot read impassively, no matter what—but *how* words work on the emotions is a mystery. A miracle. A part of someone's soul (in this case, mine) detaching from its happy bodily abode and floating over there through this dotted "i" into a stranger's (yours). With no loss of bodily abode from me. Amazing, isn't it? But people are too self-

conscious to admit their own self-conscious-ness—they don't want to tell you that they really loved your book, aside from all the stats and info cleverly disguised as entertainment, was everything in it that was about *them*. What's so socially inhibiting about that? After all, that's *why* we read novels or go to films or visit muse-ums, isn't it? To discover our own selves? To feel, ultimately and inspiringly, that we are not alone in this haphazard adventure of being a human with personal mass and personal doubt? To see, through the windows and the mirrors of art, how others have scraped by, made and make ends meet, fall in love, mend their hearts, suffer, forgive, risk a moment of truth, hazard the fleeting creation of beauty? To want to know who you are, what you have in common with others, and what makes you individually unique is a good kind of selfishness—to invoke not the self of the artist, but the self of everyone *but*. That's why art is a threat to the life of a tyranny. Tyrannies want to control the you-ness of you, they want to standardize you. Art doesn't *make* you think, it allows you to. It invites you to. It permits you to feel what you want. And *that*— the freedom to have your emotions aroused—is what devils the censor. In the mind of the cen-sor, art should exist to confirm what is already known, already acceptable, what is nifty and spankingly bland as a pre-moistened, individu-ally wrapped stamp of approval.

And, although it's clear, looking at this col-lection, that Sondra sometimes gets that feeling in her stomach over a classically pretty, senti-mental image—or an icon, even, something as frequently reproduced as Ansel Adams's *Moon-rise, Hernandez, New Mexico*—neither the portrait content of the picture nor its emotional message is her reason for deciding to purchase a photograph. At least three of the photogra-phers in her collection (E. J. Bellocq, Robert Mapplethorpe, and Sally Mann), have been targeted by censors. She is as emotionally responsive to Diane Arbus as she is to Imogen Cunningham, to Weegee as she is to Edward Weston. She and her husband, Celso Gonzalez-Falla, have, in fact, no set rules, no command-ments carved in stone, no determinants when it comes to purchasing an addition to the collec-tion. Except, each one—Sondra and Celso, each—has a veto over the other.

And every photograph must be a vintage print.

. . .

Vintage wine, vintage clothes, vintage cars— *vintage prints*? The word *v-i-n-t-a-g-e*, according to my Oxford dictionary, can mean "of a past sea-son"; but, in its accepted usage as a descriptive photographic term, it refers specifically to a print made at roughly the same time as the neg-ative by the photographer himself or by a person or procedure satisfactory to the photographer.

Every day, of the hundreds of photographs that pass in front of us—in magazines, ID cards, newspapers, and advertising—the artistic provenance of a photographic print may not seem like such a big deal; but to the photogra-pher and to the collector of photographic art, maintaining control over the artistic rights of a negative or owning a vintage print is *the* most important aspect of a photograph's historical and commercial value. In a medium whose chief access to the general public is the case in which it can be reproduced, photographers must safe-guard their artistic resources like crazy against the overwhelming probability . . . that title to their work will slip away from their control, and that they, as individual worker bees in a society finely tuned for mass production, will end up being cast as widget makers. Buying a postcard of an Ansel Adams print at your local tourist trap is not the same as owning a print made by that master printer. If you've never held a hand-printed photograph in your hands, and seen and felt the difference between it and the snapshots that we've all had processed indiscriminately, at the drugstore or through the mail, then you'll have to take it on good faith from me that the difference between the two is comparable to the difference between the way a newly minted, crisp one-hundred-dollar bill feels and looks, as compared to a piece of confetti. A handprinted, black-and-white photograph has a life of its own, an inner light heightened or tempered by the

reflective properties of the chemicals used in its printing, by the type of paper on which it is printed, by the length of time its light-sensitive constituents are exposed to a light source in a darkroom—even by the mercurial skin properties in the hands of its printer. If the classic caricature of the amateur photographer is a gadget-laden, light meter–wielding *nerd*, then the classic cartoon figure of a printer might be that of a dust-fearing, tirelessly perfecting, frustratingly exacting, impossible-to-please control freak. There are those who believe that the art of photography is really *only* about the heroic myth of the photographer Being There, wherever There happens to be with a camera—at the *decisive moment* . . . and there are those who believe that the art of photography is really only achieved in the manipulation of the negative by the printer in the darkroom. Walker Evans, for example, had this to say about his heroic version of the camera-toting photographer as an artistic gun-slinger:

"It's as though there's a wonderful secret in a certain place and I can capture it. Only I can do it at this moment, only this moment and only me. That's a hell of a thing to believe, but I believe it or I couldn't act. . . . I feel myself walking on a tightrope instead of on the ground. With the camera, it's all or nothing. You either get what you're after at once, or what you do is worthless."[1]

But Walker Evans *as a printer* sang a different tune: he was a notorious manipulator of his prints through selective cropping. And he was plowing his art in those days—not so long ago—before the virtual reality of computer-generated imagery. So is the very concept of a vintage print just another way of mummifying, just another method with a built-in obsolescence for recycling something from the past, reconstituting yesterday's old news? You bet. Every vintage print is a bit of old light captured under glass. It's a galaxy of light pinned down on paper. A dying constellation looked at from its future, when its future is our now.

. . .

It thrums.

I can feel it radiating from its hidden source into my palms, where I'm balancing it, my fingers splayed against its back, I'm so afraid I'll leave a trace on it, a fingerprint. I'm so used to seeing these images displayed on the walls of Sondra's staircase—that is joy enough. That is, for me, sufficient joy, joy *plus*, to borrow Edward Weston's phrase. Ever since I first came here on that autumn evening four years ago, the light on the stairs at Sondra's and Celso's house has been some of my favorite light in the world.

"They interact with one another," Sondra is saying—"they" being the photographs—and, to tell the truth, I'm only half listening to her, although I know I should be giving her my complete attention for this interview: but my palms are thrumming. I'm holding the Brassaï. And it's—how can I say this?—singing?—speaking? *Communicating*.

For the purpose of this book, the light on Sondra's stairs has been disturbed, some of the photographs have been taken down, taken from their frames, to be rephotographed. Hence, my holding this Brassaï. This unframed Weston, which seems so much smaller than I'd expected, so much more fragile: this familiar image that I've only seen reproduced in books, on postcards and—I consider myself lucky—under glass on Sondra's stairs. But now I'm holding it, and here's his signature in pencil, proof, proof *plus*, that he was there, alive and seeing, in that room, on that specific day in California; and am I nuts to want to jump out of my skin for the chance to tell him, "Thank you"?

. . .

Being human is contagious, when you let it be— joy is infectious. One minute you're convinced you've just about seen everything, and the next minute something comes along and hits your eyes with an unanticipated revelation.

We're sitting cross-legged on the floor at the top of Sondra's stairs, and I am staring at a picture. There are four of us bent over the archive boxes the photographs are in—Sondra, Celso, me, and my daughter Lara, who is a photographer. We've been staring at these pictures for hours now, and our legs and backs are stiff. Sondra, who is a tiny woman to begin with, is in her stocking feet, her face washed clean of any artifice as if she's just awoken, and in this light she looks about thirteen years old. She's just said, "They interact—they play with one another," and I've understood exactly what she means. But now Celso has unwrapped the Kertész that has been returned from being photographed, itself—the one called *Cyclist, Paris 1948*—and Lara has leaned forward, pointed to a square, white shape in the photograph and said, "What's that?"

We all stare.

Sondra looks at Celso, Celso looks at Sondra, and Sondra says, "I've never noticed that before, have you?," and we all start to laugh. All morning and all through the previous day, I have marveled at their joint recall of facts about each photograph—their collection, only a fraction of which is reproduced here, numbers in the hundreds, and they can name each one. *And* tell you where and how they purchased it and when it came into the collection. They are full of little anecdotal details about each photograph, the way the best teachers can recall each class of students over twenty years—but when I ask them for the names of a couple they had dinner with last week, it takes them several minutes to remember. They have the most informed sight, between the two of them, that I've ever known between a couple, but now they are marveling over this white square Lara has discovered. All of us have seen the picture countless times—Sondra and Celso have passed it on their stairs for years—but suddenly this familiar image has hit us in the eyes with something new, and Sondra's saying, "See? It's amazing—you can notice something different every time."

. . .

Maybe that's the reason for my gratitude, the reason I am grateful to these artists: not for reinventing the known world, but for revealing it. Had I a different life, I'd love to live in the light that shines on Sondra's stairs—as it is, my passion for collecting is a bit more modest in its means, but no less in its fervor. I'm an amateur geologist. In my spare time I gather rocks. I take off for a few days to the windy shores of England to hunt fossils held in cliffs or tossed by storms onto the beaches. And when Sondra mentioned that the pictures on her staircase play with one another, I was reminded of the childhood fantasy of toys that come out to play at night in the darkened toy shop—and I was reminded, too, of standing on the beach at Whithy on the Channel, looking at the light skip over thousands of smooth stones and marveling at the randomness with which they'd been assembled by the sea, created over time by several cataclysms, each one a thing of individual context, but collected on the beach by circumstance, and how they played with one another to create a landscape only I could see, a thing of monumental— if only temporary—beauty.

So imagine, too, what I feel after hours of purposefully searching, after a morning of purposeful staring, when my eye sees a fossil on the beach—one, among ten thousand stones, one among a million—a picture etched in rock, a fingerprint of time that has been waiting forty thousand years for me to pick it up and take it home.

So stare, as Walker Evans so wonderfully wrote from Paris to a friend half a century ago. Learn something. And be grateful. His mother had taught him that to stare was impolite, so he had to teach himself to do it. "*Stare*," he wrote his friend (and I'll end with his beautiful advice):

"It is the way to educate your eye, and more. Stare, pry, listen, eavesdrop. Die knowing something. You are not there long."[2]

Thinking About Photographs

Adam D. Weinberg

When Sondra Gilman began collecting photography, in the mid-1970s, it was under the influence of John Szarkowski, then the director of the department of photography at the Museum of Modern Art in New York. As she said recently, "we all learned from John." And, in the '70s, when the name "John" was used in connection with contemporary photography, everyone knew to whom it referred. After seeing the works of the turn-of-the-century French photographer Eugène Atget exhibited at the Modern, she felt as if she had been thunderstruck. Never before had she realized that one could make art with a camera.

Shortly thereafter, when the museum decided to sell duplicate vintage prints from its extensive Atget collection, Gilman spent a day with Szarkowski, finally selecting three prints to acquire. This was a fitting place to begin her collection, for Atget was the photographer Szarkowski had singled out as a master, eventually organizing a series of four exhibitions devoted to every facet of his work. As he wrote of Atget in 1973, "He was a photographer of such authority and originality that his work remains a benchmark against which much of the most sophisticated contemporary photography measures itself."[1] Gilman then purchased prints by many of those photographers featured in the Museum of Modern Art's collection and exhibitions, among them Alfred Stieglitz, Walker Evans, Edward Weston, Harry Callahan, and other "high modernists." She maintains an abiding interest in these artists' work and continues to collect them in depth.

From Szarkowski, his exhibitions, and his books, Gilman learned how "to see" photographs. She learned to recognize and experience the magnetism of a well-made picture, regardless of whether it was by a famous photographer or a relative unknown. By the late '70s, as Gilman gained confidence and experience, she ventured off on her own, formulating her own model for a collection. Together with her husband, Celso Gonzalez-Falla, she diverged from Szarkowski's vision of modern photography and expanded her collection to embrace many of the artists excluded by the Museum of Modern Art's canon.

When Gilman says, "We all learned from Szarkowski," she also speaks for this author. As a budding historian of photography, I, like many of my generation, found Szarkowski's concise and elegantly written books *The Photographer's Eye* (1966) and *Looking at Photographs* (1973) to be invaluable sources, even well after I recognized the limitations of his approach. Indeed, his method was one of the first coherent and accessible systems for looking at photographs that was not based simply on a chronological account of the history and technology of the medium as it had been delineated by such predecessors as Beaumont Newhall and Helmut and Alison Gernsheim.[2]

When Gilman and Gonzalez-Falla invited me to curate an exhibition from their collection that would be exhibited to audiences largely unfamiliar with the history of photography, I recalled the usefulness of *The Photographer's Eye*. It was thus my hope to reconsider and adapt this book's structure to reflect both the development of their collection and their reliance on the current thinking about photography at the end of the century. A comparison of Szarkowski's approach with the one I have derived from it will also reflect the evolution of the medium and critical responses to it.

In the introduction to *The Photographer's Eye*, Szarkowski begins, "THIS BOOK IS AN INVESTIGATION of what photographs look like, and why they look that way. . . . "[3] He then goes on to identify five structures for looking at photo-graphs: The Thing Itself, The Detail, The Frame, Time, and Vantage Point. These approaches were based on the Modernist view that held certain features to be unique and intrinsic to the medium itself. He maintained that there were particular characteristics of photography inherent to and determined by its tools and materials, unlike those of painting, drawing, or printmaking. To Szarkowski's mind, the best photographs were made by those photographers who took these characteristics into account and exploited them to their fullest. In his democracy of formalism, all genres and uses of photography were on equal footing: scientific photography, photojournalism, documentary, and art photography all could be measured by the same criteria.

For Szarkowski, making photographs was an experimental process that was concerned with itself. It was both a window onto the world and a mirror of the artist's own sensibility as expressed through the optical, mechanical, and chemical properties of the medium. His scheme provided a basis for judging the quality of photographs, but, like "the frame," it necessarily excluded much from consideration. His approach was appropriate to an examination of photography's formal aspects, as long as a photograph was pure and unadulterated by the intervention of the artist's hand in modifying the negative or print. His position privileged "straight" photography as defined by Ansel Adams: "photographs that looked like photographs, not imitations of other art forms. The simple straight print is a fact of life—the natural predominant style for most of photography's history."[4]

But photography is not pure now, nor was it then. A photograph cannot refer *only* to itself and its own processes. A photograph always signifies something, in fact many things. To look at a photograph merely as formal invention is to ignore a photograph's multiplicity of potential meanings. What is the context in which it was taken? For what purpose was it taken? How was it subsequently used? How is it "read" by different audiences, in different contexts, at different times? What does it mean in the context of the photographer's work? What social, historical, and scientific associations does it yield? Most of all, what does it reveal about the culture in which it was made?[5]

It should come as no surprise that photographs are not neutral carriers of fact; they're no more objective than a photographer or, for that matter, any person can be. While the camera seems to present facts, the selection, framing, and presentation of those "facts" are colored by the psyche of the photographer and reflective of larger cultural attitudes. Consider, for example, Edward Weston's *Cabbage Leaf* (p. 59), an acknowledged masterpiece of twentieth-century photography. This picture is typically hailed for the way in which the photographer has transformed a mundane leaf into an exquisite, abstract, sensuous form. However, this image must also be understood as an example of Weston's use of photography to objectify the world, particularly women and forms in nature. In his work of the late 1920s and early '30s, vegetables (in particular peppers and cabbages),

shells, and nudes are used interchangeably—an expression as much of his sexual appetites as of his desire to discover archetypal forms.[6] While the cabbage is indeed a delectable image to behold, what gives it power is its distinctively sexual connotations. It is in fact this sexual charge that separates his work from that of his innumerable copyists. This is not to say that Weston's images cannot be enjoyed simply for their aesthetic value, but that to reduce an image, any image, to mere form is an impoverishment that leads to misunderstanding.

Post-Modern photography, that is photography that exposes the ideology of picture-making, has taught us to question the notion of the purely formal. It compels us to look at pictures skeptically and to challenge romantic conceptions of inspired invention and originality. For example, in contrast to Weston's cloaked sexual metaphors, Laurie Simmons openly critiques the relation between sexuality and violence. While *Walking Gun* (p. 73) is theatrically composed and can be appreciated for its humor and beauty, Simmons literally objectifies the female form by using toy models, and ridicules Hollywood depictions that prey on women. This work is in part self-critical, in that it asks the viewer to question by whom and under what circumstances the image is made.

It was one thing to look at straight photography in the '60s through the eye of a formalist interpreter such as Szarkowski (though perhaps even then it was questionable); it is quite another to look at them now, thirty years later, through the same lens. Today's "channel-swimmers and net-surfers" are bombarded with more images than ever before. It is crucial that we develop a more critical sense not only of the images of art, but of all images. For it is on the basis of images, more so perhaps than on other forms of information, that we make our daily decisions: what to buy, who to vote for, and most importantly, what to believe. Art is not self-contained, isolated from the other images of the world. The styles and strategies of contemporary art and photography are quickly co-opted by the media and advertising. Equally, much of contemporary art and photography depends on borrowed looks and imagery from the mass media. For example, in Cindy Sherman's *Film Still #53* (p. 79), the artist, who stars in her own pictures, seems to play the part of the "good girl" in a '50s B-movie.

This does not mean we must deny beauty and pleasure or suspend all belief in the emotional and transcendent qualities of art in favor of

cultural analysis and critique. Transcendence is one thing, escapism or denial another. There is, after all, satisfaction to be had in seeing things as they are—which means comprehending what images might signify, as much as how they look. When one looks at David Levinthal's photograph *Untitled* from the 1977 book, *Hitler Moves East* (p. 92), its wit and pathos are unmistakable; however, its implications about how war is covered, manipulated, and fabricated by the media are also essential to the meaning of the work. The critical character of this image, seen in isolation, is somewhat hard to determine. In the context of Levinthal's book, the pictures are organized in five chapters outlining the campaign on the Russian front from 1941–43. Each chapter begins with an historical text by the cartoonist Gary Trudeau. Levinthal's fictitious, but credible and touching photographs—interspersed with quotes, maps, and other graphics—describe the bitter facts of war, creating tension between what is real and what is not.

It is necessary to point out that all of the images included in this volume are removed from their original contexts, as they are in the Sondra Gilman Collection. For example, in the first section, "Marking Time," Alfred Stieglitz's *Equivalent*, 1923 (p. 25), was among the dozens of cloud images he took for aesthetic purposes as expressions of "my most profound life experience, my basic philosophy of life."[7] Harold Edgerton's *Bullet, King of Hearts* (p. 28) was made by a scientist who worked at MIT for more than fifty years and always insisted, "Don't make me out to be an artist. I am an engineer. I am after the facts. Only the facts"[8]; while Danny Lyon's *The Domino Players, Walls Prison Texas* (p. 30) was one of many images made in 1968 in six Texas prisons in "an effort to somehow emotionally convey the spirit of imprisonment shared by 250,000 men in the United States."[9] It was one of seventy-six photographs he published as *Conversations with the Dead*, together with text from prison records, convict writings, and extensive contributions of letters and drawings from one particular inmate.

Gilman and Gonzalez-Falla have assembled an extraordinary group of Modernist and post-Modern images that are meaningful to them. Their collection provides a Modernist context that emphasizes the power of individual photographs, stressing their formal similarities rather than differences in content and context. While it is not possible or appropriate to attempt a detailed, image-by-image analysis here, the quotes and short biographies that accompany each image suggest an incipient means of approach. Even so, it is important to appreciate that each photograph was originally made with a distinct purpose in mind, could be presented in various ways—in books, magazines, art and non-art exhibitions—and has been received and understood differently by different audiences. The challenge therefore is to approach these works in a spirit of inquiry and not merely admiration, to look beyond surface aesthetics and remember that, paradoxically, a photograph conceals far more than it discloses.

This volume is arranged in five thematic sections. "Marking Time" and "Uncommon Familiar" acknowledge the utility of formal analysis, echoing Szarkowski's themes of "Time and Vantage Point." The other themes, "Picturing Pictures," "The Divided Self," and "Telling Tales" are largely counter to Szarkowski's thinking about photography. These three themes place a premium on what photographs signify and how they function. The themes are not, however, intended to define the pictures. Therefore, one finds photographs by the same photographer in more than one section. Also, as this book is intended to reflect the character of the Sondra Gilman Collection, the inclusion of multiple images by a single artist does reflect particular strengths of the collection.

Like *The Photographer's Eye*, this too may be thought of as "AN INVESTIGATION," not just of what photographs look like, but of what they might signify. The purpose here is to suggest that even those photographs of the most formal, abstract variety do embody cultural beliefs. Photography is not of one style or school. It is not pre-Modern, Modern, or post-Modern. It is not for one use, of one meaning, or of one context. Photographs are also chameleon-like and unstable. They are free-floating bits of visual information that can be applied to many purposes at will. Therefore fixed and enduring criteria for comprehending and judging photographs are not possible but must be continually reformulated to the problem at hand. As you examine and enjoy each picture, think to yourself, is there something more than meets the eye here? Let this be the beginning of your looking, reading, and research. The subject has been a source of much pleasure and reflection for the collector who has gathered these images. So may it be for you.

1 Marking Time

Photographs are markers, indicators. They function like index tabs holding a particular place which can then be referenced at a particular time. They seem to point to a segment of time that can be as brief as the photographic apparatus and materials will permit, or as long as the photographer chooses to leave the lens open. Some pictures appear to show time itself in action, such as Peter Hujar's *Chloe* (p. 32) while others seem to bespeak time, such as Richard Misrach's *Outdoor Dining* (p. 33).

For much of the early history of the medium, photographers anxiously sought to perfect methods to make "instantaneous photographs," that is, pictures that appear to sharply freeze motion. This was achieved on a limited basis in the 1870s, some thirty years after the invention of the medium, and became commonplace by the end of the nineteenth century. The idea of the "decisive moment," a term coined by the photographer Henri Cartier-Bresson to characterize a photograph such as André Kertész's *Cyclist, Paris* (p. 24), became one of the hallmarks of "good" photography during much of the twentieth century, especially in the United States (although many photographers did not subscribe to this idea). Images that seemed to reveal information through sharp representation tended to be prized over photographs that seemingly concealed or made their subjects indistinct through blurring and time exposures. There is no doubt that many of the most beautiful and memorable photographs made during this century are "decisive moments" that seem magically to stop movement in its tracks. However, it is important to recognize that both sharp and blurred photographs are constructs. Both are versions of experience, evidence of the fact that photography fabricates as much as it records. Neither is more true or more real. The question is how and why does the photographer use time? And, to what purpose? What we see are characterizations of time that may be captured in the form of a single image or multiple sequences of images. Just as time can be described in an infinite number of ways by writers, so too can it be variably configured by the photographer.

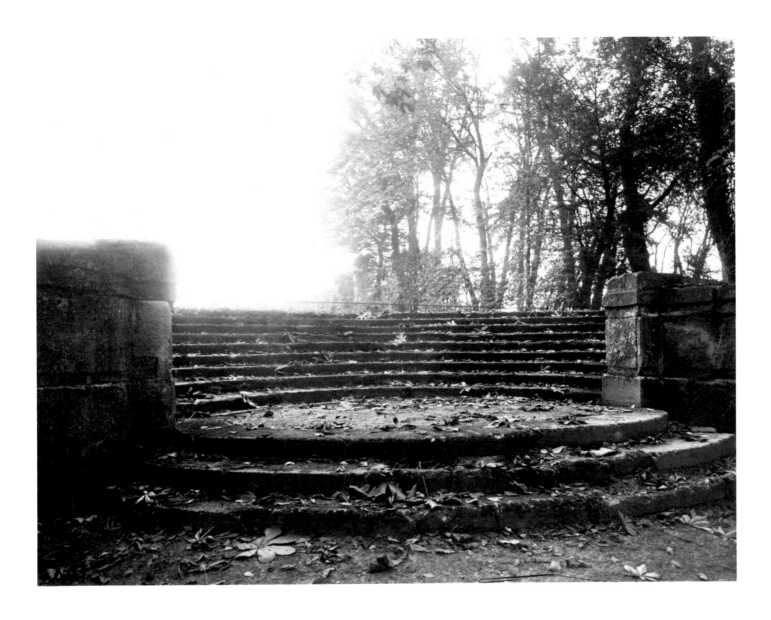

"For more than twenty years, through my own labor and individual initiative, in all the venerable streets of Old Paris, I have been making photographic negatives. . . . This enormous artistic and documentary collection is today complete. I can truthfully say that I possess all of Old Paris."

In need of a reliable income, which his work as an actor and a painter had not provided, Eugène Atget became a commercial photographer in middle age. He recorded the boulevards, cul-de-sacs, and gardens of Old Paris and its environs, with a distinct purpose in view. Atget sold his pictures as reference material to a diverse audience—from architects, museums, and publishers, to artists and designers. Firmly rooted in the working-class culture of nineteenth-century France, Atget was surprised and somewhat irritated by the attention later given to his photographs by the Surrealists. When Man Ray requested a picture for *La Révolution Surréaliste* in 1926, Atget demanded that his name not be credited, stating, "These are simply documents I make." Through the efforts of Berenice Abbott (who was studying with Man Ray at the time), a substantial group of Atget's 8,500 or so images were acquired by New York's Museum of Modern Art. Devoid of artifice and inhabited by Atget's particular view of life, these "documents" have come to be regarded as cornerstones of modern photography.

Eugène Atget
French, 1857–1927

Fallen Leaves on Steps,
no date

Comic Dive Team,
San Francisco, 1939

"Most important to me is the meaning of my photographs, the finding of subject matter significant for myself and, hopefully, for the viewer. . . . I am not addicted to aesthetic perfection and technical fetishism. I want my pictures to be read for the expression of my feelings and for the information in my visual discoveries."

20

John Gutmann
American, b. Germany, 1905

Armed with an expensive camera and a press card, John Gutmann assumed the guise of a photojournalist in order to escape Hitler's Germany in 1933. The former painter moved to San Francisco, where he promptly assumed his new role, photographing American life for European magazines. Relying on his "painter's consciousness," Gutmann intuitively knew how to get good pictures that would sell. At the same time, he began creating an enormous body of experimental work that resonates with "the marvelous extravagance of life" he found in his adopted country. Gutmann applied aspects of the medium that made for good photojournalism, such as dynamic framing and close crops, with selective focus and purposeful blurs that conveyed his innovative view of life's multiplicities. These departures from straight photography, in which technical perfection was paramount, were then regarded by purists as the sort of lapses that marked the amateur snap-shooter.

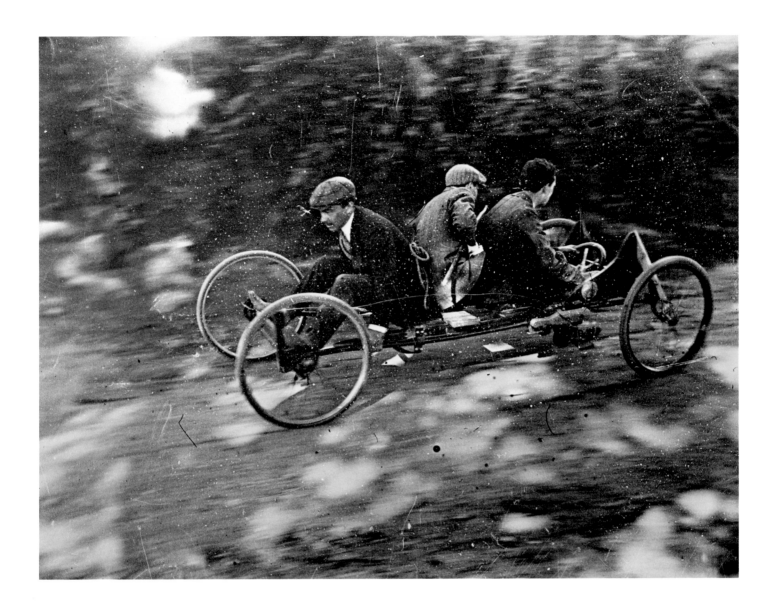

"My memory, a sort of file installed in my brain, keeps things, things in the process of happening that immediately become of the past. There I recover dates, facts, data, but nothing of the mysterious imponderables that enchant me and that I love and that love me, then escape."

At the age of seven, Jacques-Henri Lartigue began photographing his family and pets with a wooden box camera he received as a Christmas present. He recorded scenes from the privileged Parisian world he grew up in, people engaged in leisure activities who were usually unposed and often in motion. On completing his studies at the Acadamie Julian in 1915, Lartigue became a painter, fashion illustrator, and filmmaker, photographing less as time went by. But his pictures capture the essence of style and accomplishment that characterized wealthy French bourgeois society between the wars. His photographs, stored in private albums, remained unknown to the American public until a 1963 exhibition of his work at New York's Museum of Modern Art. With the centenary of Lartigue's birth, numerous publications have brought his remarkable images to an international audience.

Jacques-Henri Lartigue
French, 1894–1986

Three Men on Four Wheels, 1910

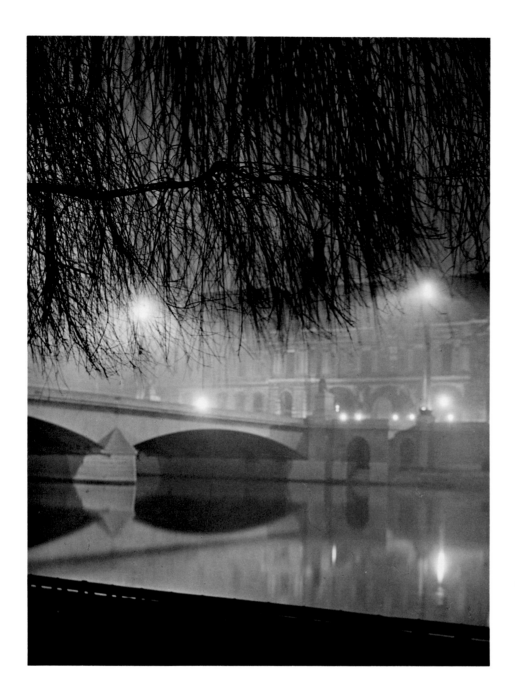

Le Pont du Carrousel
et le Louvre, 1946

"The object is absolutely inimitable; the question is always to find that sole translation that will be valid in another language. And . . . there is the difficulty of being faithful to the object, the fear of betraying it . . . which obliges us to recreate it or reinvent it. . . . In a word, I invent nothing, I imagine everything."

Brassaï (Gyula Halász)
French, b. Austria-Hungary,
1899–1984

Brassaï renamed himself for Brasso, his birthplace in Transylvania, after moving to Paris in 1924 to work as a journalist. He began photographing around 1929, under the guidance of his friend André Kertész. Brassaï became witness to Paris's nocturnal panorama—its cafés, brothels, and dim alleys. His first collection, *Paris du Nuit*, published in 1933, launched his career. Brassaï photographed for European magazines including *Harper's Bazaar*, *Realities*, and *Minotaur*, designed for the ballet, incorporating his photographs into his set decor, and also became known for his portraits of avant-garde artists and writers of the time, many of whom collaborated with the photographer on book projects. Henry Miller called Brassaï "the Eye of Paris . . . [he] has that rare gift which so many artists despise—*normal vision*. . . . He would not alter the living arrangement of the world by one iota."

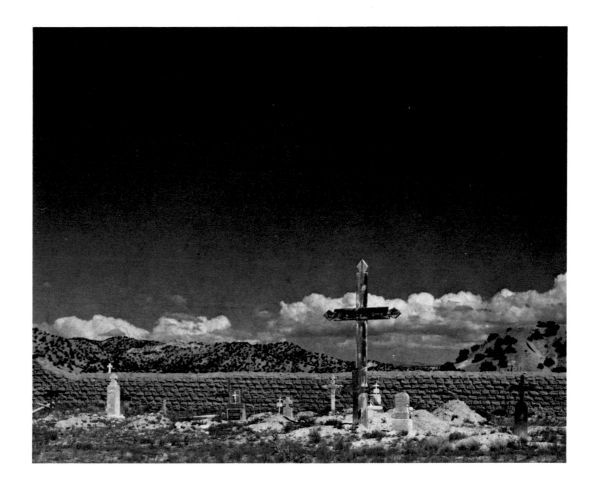

Campo Santo, 1932

"The material of the artist lies not within himself nor in the fabrications of his imagination but in the world around him. . . . The artist's world is limitless. It can be found anywhere, far from where he lives or a few feet away. It is always on his doorstep."

In 1911, Paul Strand established himself as a freelance commercial photographer in New York, where he frequented Alfred Stieglitz's "291" Gallery. Stimulated by the new vision of the avant-garde photographers and artists exhibited there, Strand created an experimental series of images that reflected the dynamism, and precariousness, of contemporary urban life. One of the first creative photographers to realize that his work would reach a broad audience only through publications, Strand produced a magnificent gravure portfolio, "Photographs of Mexico," in 1940. Following his first one-person exhibition at New York's Museum of Modern Art, in 1945, Strand published two landmark books, *Le France de Profil* (1952), and *Un Paese* (1955). Over the years, Strand worked closely with publishers and printers, making an immeasurable contribution to the art of the photographic book.

Paul Strand
American, 1890–1952

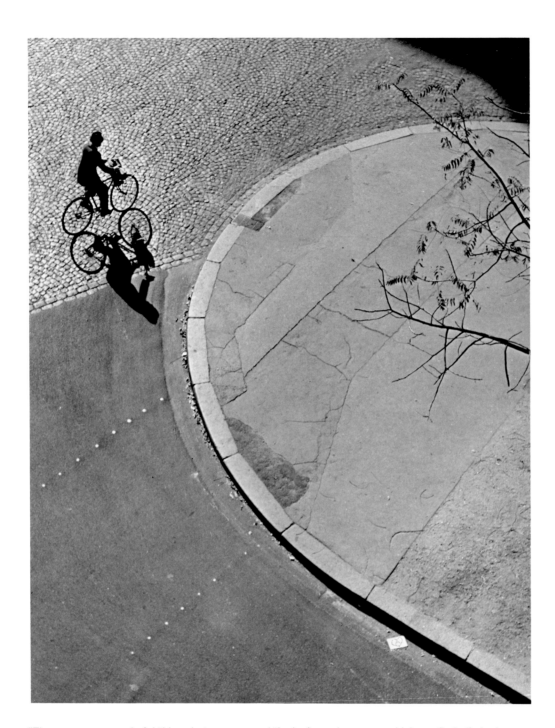

Cyclist,
Paris, 1948

"There are many wonderful things between you and the horizon when you are high up. So I climbed up church towers and mountains."

André Kertész
American, b. Hungary, 1894–1985

André Kertész was one of the first photographers, along with Henri Cartier-Bresson, to fully exploit the small, handheld 35mm camera introduced by Leica in 1925. Kertész established a freelance career in Paris, shooting for European picture magazines that flourished during the 1920s and '30s. His photographs captured the simultaneousness of seeing, experiencing, and freezing an instant on film—an aspect of photography not possible with the large, slow cameras then in use. When Hitler's aggressions escalated, Kertész moved to New York, where he freelanced for *Vogue* and *Town & Country* magazines, among other publications, and virtually disappeared from the creative photography scene he had helped to create. On retiring from commercial work, Kertész focused on book and exhibition projects, culminating with a major retrospective organized by the Art Institute of Chicago in 1985.

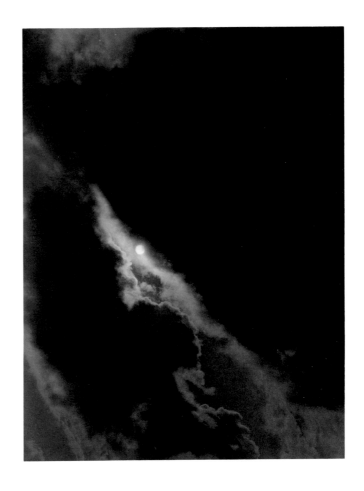

Equivalent,
1923

"What is of greatest importance is to hold a moment, to record something so completely that those who see it will relive an equivalent of what has been expressed."

Photographer, writer, teacher, and mentor, Alfred Stieglitz is often referred to as "the Godfather of Modernism" in America. Through the Little Gallery of the Photo-Secession (known as the "291" Gallery) and writings in his influential magazine, *Camera Work*, Stieglitz played a central role in bringing recognition to photography as an art form. He exhibited and nurtured a generation of America's foremost creative photographers (Paul Strand, Minor White, and Francis Brugière, among others) through periods of experimentation and struggle. In 1912, Stieglitz shut down "291" and *Camera Work* to devote himself to his own photography, beginning with a series entitled "Equivalents," one of which is reproduced here. As a photographer, publisher, and art dealer, Stieglitz worked tirelessly to advance the idea that a photograph could stimulate powerful emotions in the viewer in much the same way a great painting or sculpture can.

Alfred Stieglitz
American, 1864–1946

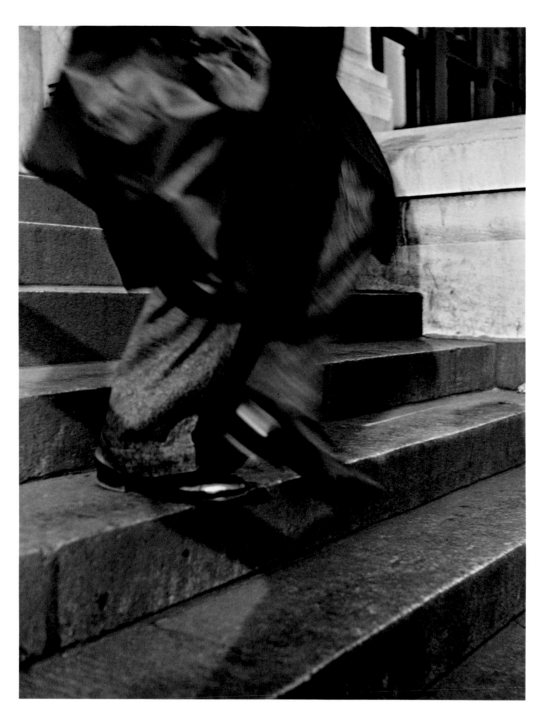

Running Legs, New York,
1940–41

"It is of importance for photographers to realize that a photograph should be a product of today, not of yesterday. It should be concerned with everything in life that is meaningful for us. Otherwise it is merely an imitation of something that happened yesterday, and lacks meaning. . . ."

Lisette Model
American, b. Austria,
1906–1983

Lisette Model, a music student in her early twenties, took up the camera in 1933 and mastered photography through a series of well-off vacationers on the Côte d'Azur. On moving to New York in 1938, Model secured freelance assignments based on the strength of that work. By the early 1940s, two of her photographs had been acquired by the Museum of Modern Art, and she was working for *Harper's Bazaar*. Under the guidance of its art director, Alexy Brodovitch, Model photographed nightlife on the fringes of society populated by freaks and gender outlaws, as well as more experimental images such as the one reproduced here. During the 1940s, Model taught photography in California, and from 1951 to 1982 at New York's New School for Social Research. There, she influenced many young photographers who would make their mark, including Diane Arbus and Sarah Charlesworth.

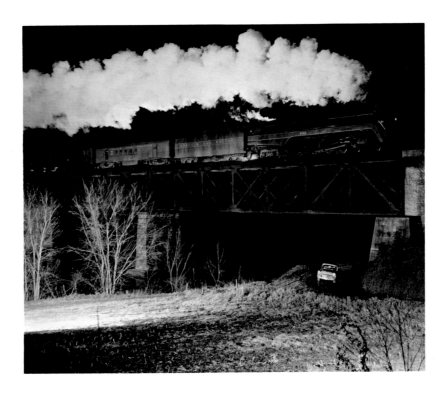

Train No. 17 Crosses
Bridge 201, East of
Wurno Siding, 1957
(NW1603)

"The train is as close to a human being as you can get. It talks, it moves, it grunts and groans. And each engine has its own characteristic—its own sounds and smells and sights."

Ogle Winston Link, a civil engineer by training, turned his skills as an amateur photographer from a hobby into a life-long career. During World War II, Link worked as a researcher and photographer for the Columbia University Division of War Research, where he had access to strobe lights used in aviation, and learned how to adapt them for synchronized flash lighting in photography. In 1955, while on a commercial assignment in West Virginia, Link discovered the subject with which he has become identified: a train buff since childhood, he was awed by the great steam locomotives of the Norfolk and Western Railroad thundering through the rural landscape—especially at night, when, set against countryside and hamlet, their majestic forms took on a surrealistic aura. Over the next five years Link returned to West Virginia many times, setting up elaborate lighting systems with thousands of yards of wiring that sometimes took several days to orchestrate. These images of the last steam-driven engines in America also portray a way of life that might have passed without notice had it not been for Link's passionate interest.

O. Winston Link
American, b. 1914

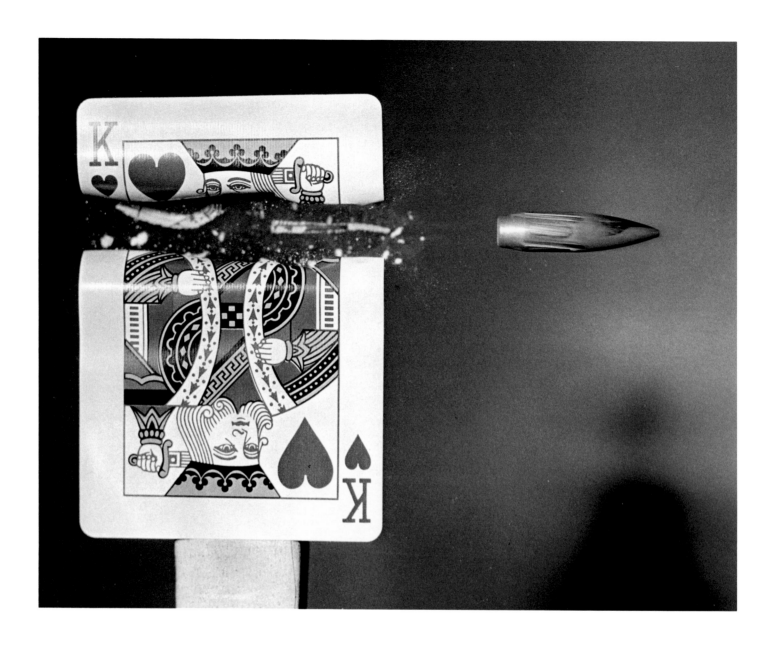

"An old article in the *British Journal of Photography* (September, 1864), when referring to William Fox Talbot's relatively weak spark experiments, stated, '. . . further progress in this direction would not be difficult.' So correct, but it has taken over 100 years for electronic flash to become a commonly used source of light for all types of photography."

Harold Edgerton
American, 1903–1990

Bullet, King of Hearts,
1960

Through his pioneering development of high-speed stroboscopic photography, Dr. Harold Edgerton changed the way we see objects in flight. In the art-dominated photography world of the 1930s (only a decade after Edward Steichen had experimented with three-day-long exposures that captured on film subtleties never before seen by the human eye), Edgerton's achievements were radical. He synchronized light discharged from neon-filled tubes with exposures made at up to one-millionth of a second, thereby enabling the camera to stop action. Edgerton's photographs were like fictions that made it possible for "time itself to be chopped up into small bits and frozen so that it suits our needs and wishes." Edgerton viewed the images he created primarily as scientific documents, yet they are also seen as realms of wonder that can be appreciated for their inherent beauty.

Chicago Rain Dance,
1957

"For some time, I have found myself discontented with . . . the isolated moment that seemingly is the dominant concern of still photography today. Instead, my work has moved into something of the composite, of collected and related moments, employing methods of combination, repetition, and superimposition. . . ."

A student of Harry Callahan at Chicago's Institute of Design, Ray K. Metzker was schooled in the new Bauhaus approach to art and design, in which experimentation would push the limits of the chosen media beyond their known capabilities. Metzker used an entire roll of film as if it were one negative, constructing composite photographs that embodied the Modernist sense of rapidly changing events, fragmentation, and synthesis. These images offer the viewer a paradoxical challenge: an urge either to accept the visual narrative for its formal, graphic qualities or to explore further and experience unseen moments that lie beyond the frame. In his later works, such as the image reproduced here, fragmentation gives way to synthesis, inviting the viewer "to look into the photograph, to see what is there and how it is related—that is, how one part is acting on another."

Ray K. Metzker
American, b. 1931

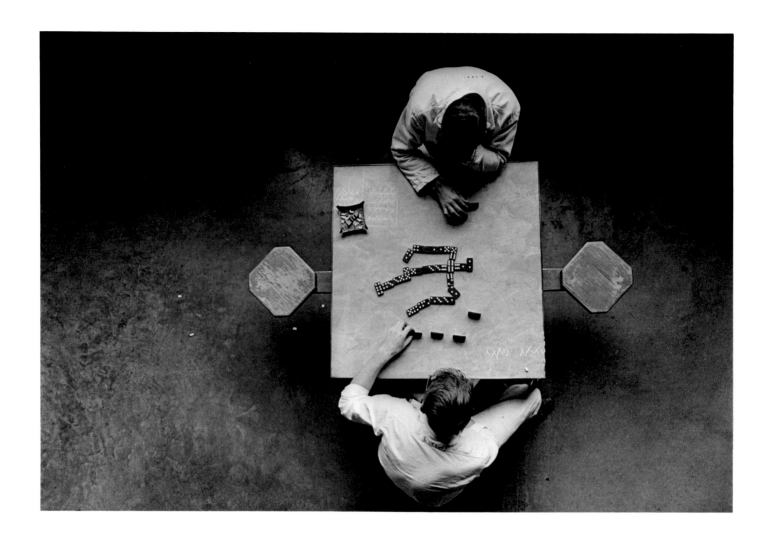

"Photographers traditionally have worked in silence, putting everything into the picture, that small area, measured in inches, that they have staked out. I have . . . usually presented my photographs in books with a text. In the texts I have spoken through other people's voices, sometimes out of respect for what they had to say, and sometimes as a disguise for myself."

Danny Lyon
American, b. 1942

The Domino Players,
Walls Prison,
Texas, 1969

Danny Lyon's involvement in photography began with his commitment to the Civil Rights movement at the University of Chicago. After winning a photo contest in 1963, Lyons became staff photographer for the Student Non-Violent Coordinating Committee there. Shot from within his own culture, Lyon's photographs reverberate with the spirit, yearnings, and anxieties of that era (see page 87). His engagement with his subjects, from the bikers Lyon traveled with in the mid-1960s to the prisoners he later photographed in Texas, mirrors his belief in the need for acceptance and understanding. In the photograph above, Lyon's overhead perspective looks in on a peaceful moment in a prison yard. By framing the image to exclude the ever-present guards, Lyon effectively presents these prisoners as ordinary men. Seen apart from the book, *Conversations with the Dead* (New York, 1971), the photograph's formal qualities usurp Lyon's original intent.

"In photography there's always a time exposure. It's time exposed onto the film. In my case it refers to the period after the photographs have been made, when the work itself will be re-exposed to actual physical time. That's why I titled it 'Time Exposed.'"

Hiroshi Sugimoto has a deep appreciation for the early practice of photography as it evolved in his native country, where the word for the medium is *shashin*, or "transforming the real." In his seascape series, which dates from 1980, Sugimoto imposes a uniformity that simultaneously invokes and questions our perception of time, place, and cultural identity. Wherever he shoots, Sugimoto frames the oceans identically: straight on, and equally divided by a horizon, an artistic device that robs the images of spatial depth. Through extremely long exposures, Sugimoto records far more detail than the eye can comfortably accommodate, imposing a manufactured reality on a world that has become increasingly homogeneous. It is the surface details of wind, weather, and time of day that restore a sense of reality to the otherwise anonymous oceans.

Hiroshi Sugimoto
Japanese, b. 1948

Ligurian Sea,
Saviore, 1993

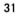

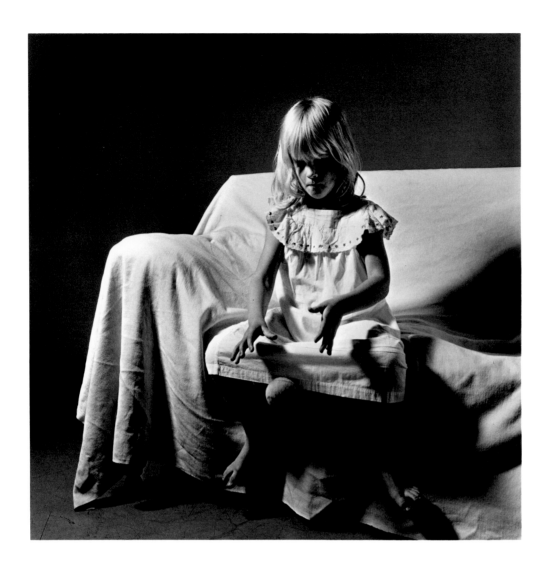

Chloe, 1981

"I think of my photographs as pieces of paper that have a life of their own. The whole story has to be on that paper. It is amazing that photographs can have such power."

Peter Hujar
American, 1934–1987

Peter Hujar began photographing at the age of thirteen, and later learned the technical side of his craft through an apprenticeship in commercial photography. He worked steadily as a fashion photographer during the 1960s and '70s, but abandoned that field to create the portraits for which he has recently become well-known. In these images, usually photographed against a stark background with few props, Hujar brings out both the drama and enigma of his sitters. His lighting seems to intimately frame them, yet psychologically distance them through abstract, sculptural shadows. Left to their own devices as to pose or activity, Hujar's subjects often display an intense inwardness: a sense of self-impersonation but also a depth of character. Nan Goldin has written of Hujar, "He was a magician, he hypnotized his subjects . . . he seduced people to want to reveal all to him."

"What's really important to me is that [my photographs] are driven by ideas. Without the idea behind it the work falls apart. I can't strip away what drives me to make the pictures look the way they do."

After a brief period as a documentary photographer in the early 1970s, Richard Misrach turned his sights on landscape. His work has evolved from experimental images that pushed aesthetic and technical limitations of color photography to images that "give credence to the possibility that the past, present, and future exist simultaneously." Their central theme is the environmental crisis in the American West. Widely known for his series "Desert Cantos," which exposes the ecocide brought about by nuclear testing and chemical waste, Misrach makes images that are laden with complexity and incongruity. The photograph reproduced here is one that both refers to and denies the romantic landscape tradition that originated in the nineteenth century, which celebrates the ennobling powers of unspoiled wilderness. Here, the lone observer of the past, one who would have benefited from nature's gifts, has vanished, replaced by icons of mass tourism.

Richard Misrach
American, b. 1949

Outdoor Dining, Bonneville
Salt Flats, Utah, 1992

2 Picturing Pictures

Photography is a medium that makes use of a preexisting subject. While a subject may have been constructed by hand, as in the cut paper creations of Francis Brugière (p. 37), or modified during any stage of the photographic process—in the camera, on the negative, in the printing, on the print or, as is common today, in the computer—a photograph begins with something that at some point was before the lens. Even before the word "appropriation" came to be used in the post-Modern sense, to denote removing an image or object from one context and re-inserting it in a different one, photographers had no choice but to appropriate their subjects from the world. Hence, photographers often use the expression "looking for a picture" as if subjects existed "out there" for the purpose of being pictured. The idea that the world itself exists as the locus for an infinite number of pictures is largely a photographic one. Every day, millions of photographs are taken by countless individuals everywhere on the planet who accept as a given the act of framing the world in the camera.

Many photographers have used the medium to make pictures of other pictures, or as a means (consciously or unconsciously) of calling attention to the act, processes, and purposes of photography. In essence, the medium is turned in on itself, questioning what a photograph is, as well as how and why it is made. For example, is Helen Levitt's picture *Untitled* (p. 43) a picture by Levitt? True, she is documenting the life and imagination of children in the streets of New York. She did find the subject, capture it, and make it her art. She did recognize the street drawing as a simple but profound image. She did choose how to crop and print it. Yet is this someone else's creation? Where is the line between creating and coopting? That such

questions are implicit in Levitt's images, and in those of Walker Evans's (p. 35, 36), is one of their strengths.

Chuck Close's *Self-portrait* (p. 40) is not a picture of a picture per se. It is a picture on the way to another picture. It bears the grid marks that the artist uses to transfer the information from Polaroid to canvas. The photograph is data, pictorial bits, which the artist scrutinizes and reconstitutes in painterly terms. The photograph is also an artwork in its own right; but like the painting, it is the artist's perceptual and aesthetic investigation into what makes a picture a picture and how one pictures a picture.

Some photographers, like Louise Lawler (p. 44) explicitly make pictures to critique the medium itself and the idea of originality. Her image is an image of an image (the Frank Stella painting) and an image of an image of an image (the reflection on the floor). This picture questions where the original work of art is located. It is also a meditation on the conditions of the art gallery as a self-contained viewing space cut off from the world. Where is the site of real experience? Or, is all experience secondhand? The point is that such photographs call into question the role of the producer and what it means to make images photographically. Even if a photographer is not literally making a picture of a picture, every photographer carries around in his or her head the experience of other pictures.

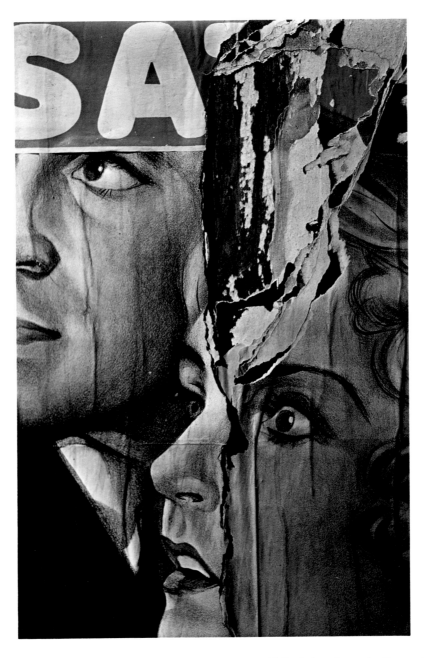

Torn Movie Poster,
1930

"When you say 'documentary,' you have to have a sophisticated ear to receive the word. It should be documentary-style, because documentary is police photography of a scene and a murder. . . . You see art is really useless, and a document has use. And therefore art is never a document, but it can adopt that style. . . . I'm called a documentary photographer. But that presupposes a quite subtle knowledge of this distinction."

Primarily a self-taught photographer, Walker Evans formed an original way of seeing the world. Disdainful of artiness and elegance, his was a clear, unromantic, unobtrusive, and at first glance, seemingly unstudied vision. Before taking up photography in 1928, Evans studied in Paris, where he became acquainted with French Dadaism. Through that experience, Evans brought a critical literacy to his camera work. In the late 1920s, he began photographing images laden with vernacular symbols: crowded, hand-lettered signs advertising everything from farm implements to soft drinks. In these images he saw symbolic manifestations of American culture and its obsessive material concerns. Carefully framing those messages, Evans created new references dense with visual metaphor. It was a subject Evans explored often in close-ups such as the image reproduced here. In sharply observed vernacular graphics, he found a purely American visual language that speaks of subtle tensions between reality and illusion.

Walker Evans
American, 1903–1975

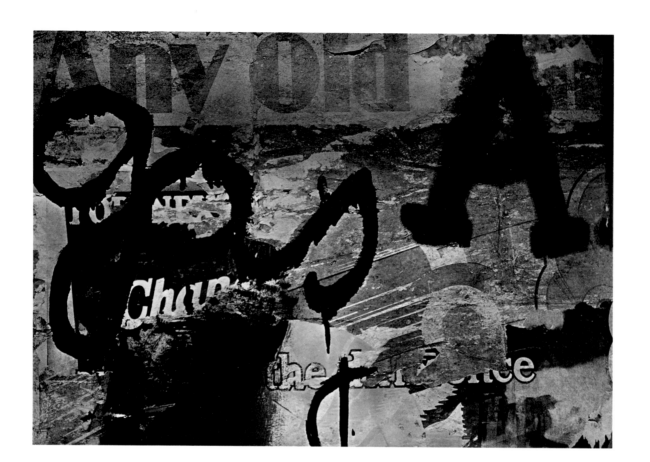

Roadside Gas Sign,
1929

Walker Evans

"I think what I am doing is valid and worth doing, and I use the word transcendent. That's very pretentious, but if I'm satisfied that something transcendent shows in a photograph I've done, that's it. . . . I know by the way I feel in the action that it goes like magic. . . ."

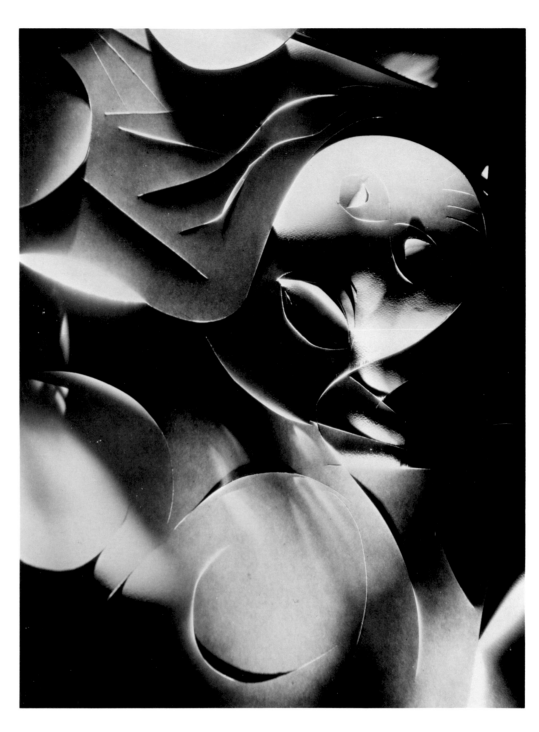

Cut Paper Abstraction,
ca. 1920

"What lives in pictures is very difficult to define . . . it finally becomes a thing beyond the thing portrayed . . .
some sort of section of the soul of the artist that gets detached and comes out to one from the picture. . . . "

Francis Brugière
American, 1879–1945

After meeting Alfred Stieglitz in 1905, Francis Brugière opened a portrait studio in
San Francisco. The "Light Abstractions" he later made offer a capsule view of the American
modernist photography impulse, which had originated in Stieglitz's "291" Gallery. Brugière
sought ways to advance the uniquely photographic qualities of photography. Form, line,
tone, and rhythm were the subject of those paper constructions, shot in multiple exposures
with subtle shifts in the light source. Brugière pushed the camera's ability to record incred-
ible detail across a tonal scale invisible to the naked eye. These "unnatural worlds" also pro-
vided a stimulating source of ideas for his commercial work for the Theatre Guild of
New York. Using similar techniques, Brugière readjusted the stage lighting to capture on
film the mood and spirit of theatrical productions as envisioned by their designers.

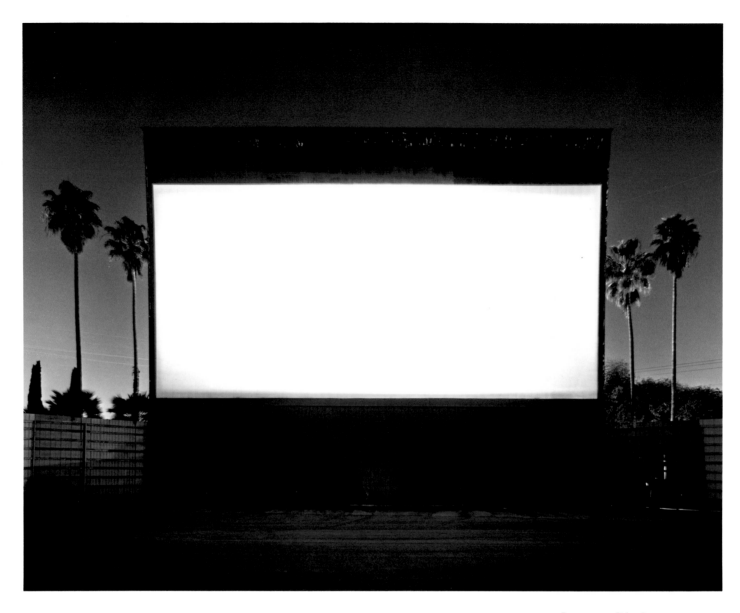

Rosencrans Drive-in,
Paramount, 1993

Hiroshi Sugimoto "People cannot really concentrate. They don't look at a thing for a long time. Our eyes are always moving
and searching for something else to see."

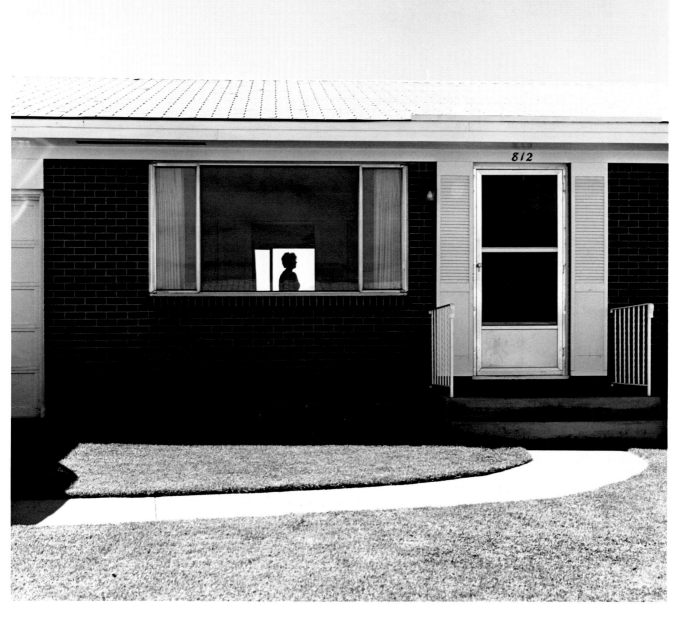

"The subject of most of my pictures is a troubling mixture: buildings and roads that are often, but not always, unworthy of us; people who are, though they participate in urban chaos, admirable and deserving of our thoughts and care; light that sometimes still works an alchemy. . . ."

Since the late 1960s, Robert Adams has made the American West the subject of his work, both as a photographer and as a writer. Although his landscapes often record the uneasy meeting of nature and human culture, Adams does not shoot from a position of moral outrage. He sees prefab houses, gas stations, and industrial plants for what they are: characteristic aspects of the region where he abides. Striving for "an unarguably right relationship of shape, a visual stability in which all components are equally important," Adams articulates his photographs with formal qualities that seem at odds with their content. Even in his pictures of tract houses, a sense of proportion and balance gives dignity to the banal habitations; nature still exerts a surprising grace, seen here in the crystalline mountain light.

Robert Adams
American, b. 1937

Colorado Springs,
Colorado, 1968

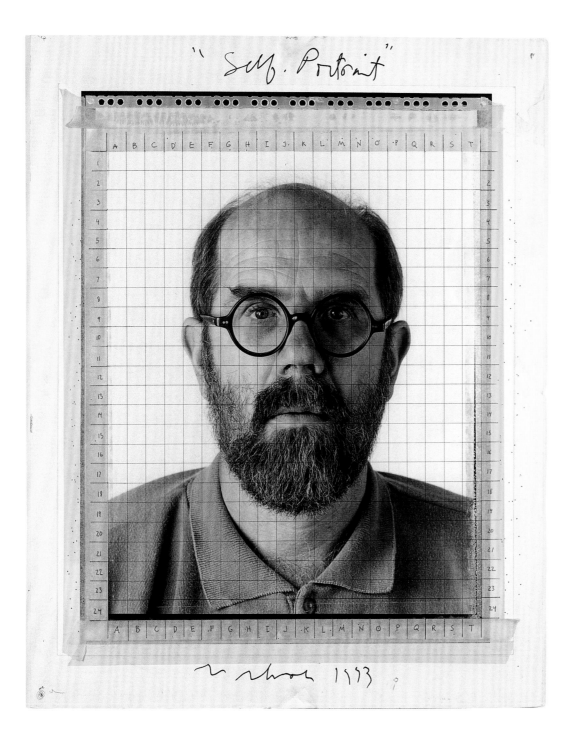

"Self-Portrait"

Self-Portrait,
1993

"It always amazes me that just when I think that there's nothing left to do in photography and that all permutations and possibilities have been exhausted, someone comes along and puts the medium to a new use . . . and makes it as profound and as moving and as formally interesting as any other medium. . . . "

Chuck Close
American, b. 1940

By his own admission, Chuck Close backed into photography as a medium of choice. Known for large-scale, hyperreal portraits of friends in the art world, Close usually made photographs of his subjects as reference material. Around the mid-1970s, Close began working in the Polaroid 20 x 24" format, whose large size, incredible sharpness, and instantaneousness offered Close new visual territory to explore. These photographs present a density of visual information that curiously humanizes their subjects by exposing their vulnerability in the form of minuscule imperfections, from hangnails to flakes of dead skin. In the image shown here, which Close used as a maquette for a painting, a scaling grid has the effect of framing many pictures within the whole, inviting even closer scrutiny square by square.

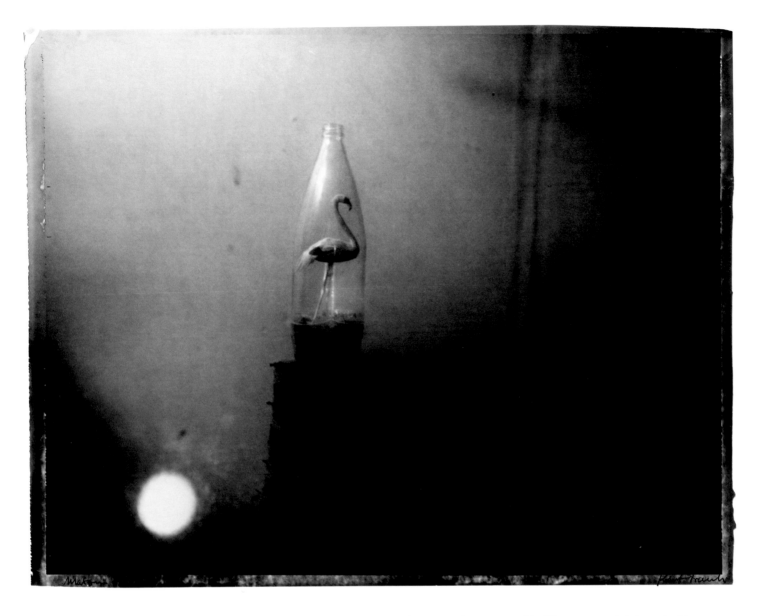

"Above all, I know that life for a photographer cannot be a matter of indifference. . . . It is important to see what is invisible to others. Perhaps the look of hope or the look of sadness. Also, it is always the instantaneous reaction to oneself that produces a photograph."

When Robert Frank traveled around the United States on Guggenheim fellowships, in 1955 and 1956, he made images that would later alter the public's perception of what makes a good photograph. Frank probed the continent, framing a troubled view of postwar America. Published in 1959, *The Americans* captured the look, feel, and sound of his encounters with ordinary people. Condemned by critics at the time for their off-kilter, casual effects—and even worse, their subjective, often downbeat view of poverty and racial division—Frank's images redefined street photography. What made these pictures so unusual at the time was the sense of Frank's own presence at the moment of their making. After devoting himself to filmmaking in the 1950s and '60s, Frank returned to still photography, and experimented with new ways to subvert the technically rigorous medium. The image here has a roughness that contrasts with the idea of "time in a bottle" conveyed by the delicate glass container and the way in which it is lighted.

Robert Frank
American, b. Zurich, 1924

Mabou, 1991

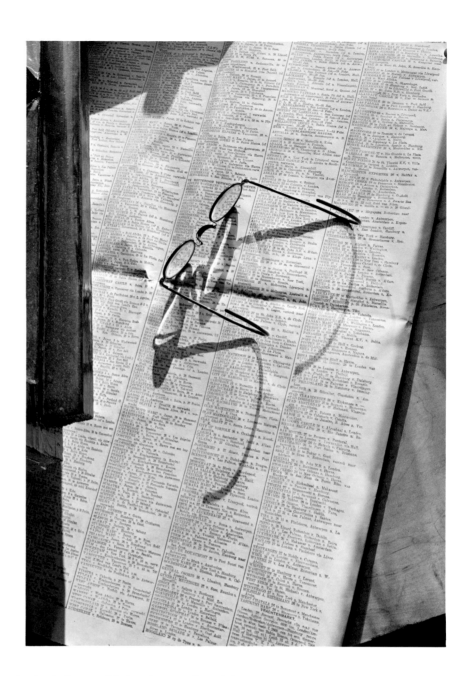

Untitled,
no date

"It is no longer important to photograph images that are pleasing to the eye: this is only camouflage: it is reaction, not progress. . . . The typographical factor adds through the word what appears necessary for the completeness of the image, not in an independent way, but in immediate functional contact."

Piet Zwart
Dutch, 1885–1977

An architect and industrial and graphic designer, Piet Zwart made photography another of his professional pursuits in the early 1920s. After meeting El Lissitzky, who taught him the principles of the photogram (photographic images made without negatives), Zwart then learned the art and craft of the medium on his own. He integrated photography and type in advertising designs that reflected the de Stijl philosophy of "new objectivity," which took a Utopian perspective on art and design. Its members, including the painters Piet Mondrian and Theo Van Doesburg, sought to "cleanse reality of its . . . accidental disorders" through abstraction, using pure geometrical forms. Zwart called himself a "typotect": one who constructs images from typeforms and photographs, much like an architect, who assembles a building from diverse materials. In his individual photos, such as the one here, Zwart brought the same ideas into play, with typography, appropriated from printed matter, incorporated into his still lifes.

"In the presence of extraordinary actuality, consciousness takes the place of imagination."

Helen Levitt is best known for photographs that capture the unexpected in commonplace activities, especially the graceful social interplay that took place on the streets of New York's ethnic neighborhoods in the 1940s and '50s. As a young photographer, she was influenced by Walker Evans (with whom she collaborated from 1938–41) and a group of Surrealist photographers who had emigrated here to escape the Nazi takeover in Europe. By 1949, Levitt was an established freelance photographer and an active documentary filmmaker, and she had had her first one-person exhibition at New York's Museum of Modern Art. Her intuitive approach, fueled by a talent for composition, is evident in the image reproduced here, which is part of a series she made of chalk drawings done by children in East Harlem. The spirited drawing, long disappeared, speaks in a haunting visual language—even more so today, when it is rare to see children playing on city sidewalks.

Helen Levitt
American, b. 1918

Untitled, ca. 1945

"A photograph is one kind of information. It can be 'read' in different ways according to its context and according to its 'reader.' I am conscious of this in the material production of my work and further acknowledge and foreground this issue with 'captions' and titles. I just read a sentence by Robert Harbison about writing a book that ended with 'giving the mind an existence outside itself.' This makes sense to me in relation to my work."

Louise Lawler
American, b. 1947

How Many Pictures,
1989

"A Picture is No Substitute For Anything." "Recognition Maybe, May Not be Useful." "Borrowed Time." The titles of Louise Lawler's printed matter projects offer clues to her subversive view of the life cycle of a work of art—and the artist's position in the economic food chain. Coming to prominence during the 1980s, when New York's art scene became increasingly antic, due in large part to a grossly inflated stock market, Lawler began investigating the phenomena and fetishisms of art ownership. With access to several important collections, she photographically recorded the owners' installations, which she then printed, mounted, and exhibited along with labels providing the specifics of each object and its placement. In the process of making politicized anti-art, critical of social conditions that dictate an artist's value, she also reveals her own enjoyment of art for art's sake, as seen in the photograph here depicting the reflection of a painting by Frank Stella.

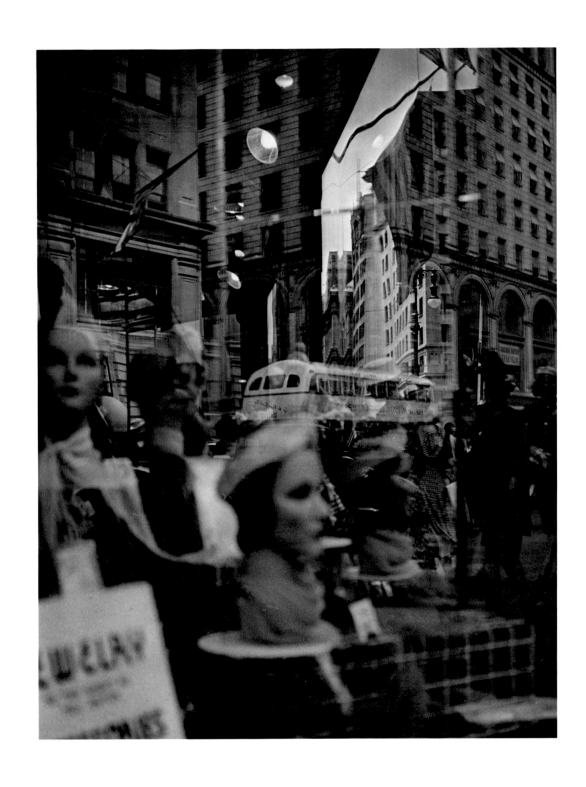

Reflections,
1939–45

"I have often been asked what I want to prove with my photographs. The answer is I don't want to prove anything. The camera is an instrument of detection. We photograph not only what we know but also what we don't know. A moment is caught that was and never will be again—and lives on in the picture."

Lisette Model

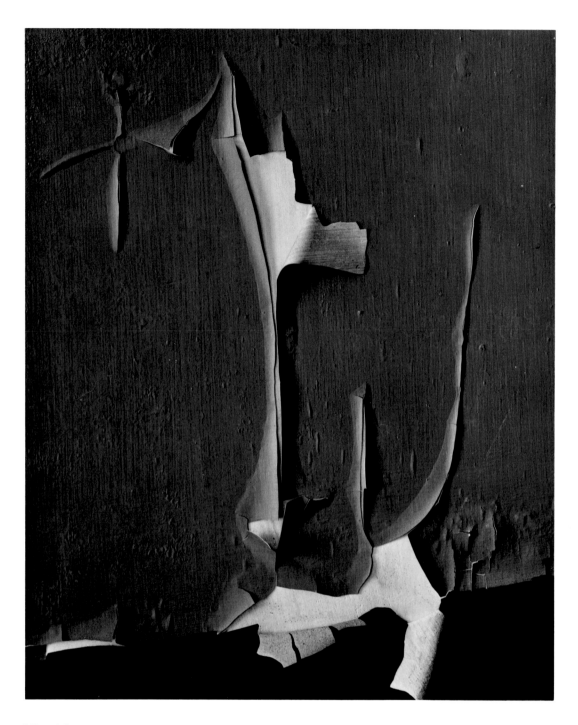

"When I feel the need of bigger images . . . enlargements won't always do. So I make constellations of photographs, or sequence them into larger images. A picture story explains and demonstrates. A sequence sustains the feeling states."

Minor White
American, 1908–1976

Rochester, 1959

Photographer, curator, educator, writer, and founding editor of *Aperture*, Minor White used the medium of photography to express meanings beyond the content of his images. Influenced by Alfred Stieglitz's concept of equivalents, White amplified that vocabulary through images grouped as sequences. Seen together, along with brief texts, they become visible manifestations of what he called the "inner landscape." For White, his camera work was a route to self-discovery and a means to affirm his conviction that nature creates its own pictures. White often made close-up abstractions that offer no clues to their relationship to human scale, yet remain within the world of appearances. He published *Rochester* in *Mirrors, Messages, Manifestations* (Aperture, 1969) as a single image, with a text on "equivalence." In 1976, he sequenced it with twelve other images in *The Jupiter Portfolio*.

"Life is the most durable fiction that matter has yet come up with, and art is the structure of matter as life's most durable fiction."

In 1931, Frederick Sommer emigrated from Brazil to the United States, and shifted his focus from landscape architecture to photography after visiting Alfred Stieglitz's "291" Gallery. Sommer then settled in Arizona, where he met Edward Weston and later, the Surrealist painter Max Ernst. Influenced by these two masters, Sommer began photographing with an 8 x 10" camera, creating disquieting tableaux composed of found objects: broken dolls, metal shards, dead animals decayed beyond recognition. Embracing the Surrealist precepts of chance, spontaneity, and juxtapositions, Sommer created visual fictions in which themes of death and impermanence play out in photographs that are formally beautiful and technically exquisite. The photograph here is part of a series in which Sommer enlisted ancient frescoes and sculptures to retell a story of matter's transient nature and gradual process of death.

Frederick Sommer
American, b. Italy, 1905

Bather, Mexico,
1952

3 Uncommon Familiar

From the moment photography was invented in 1839, viewers marveled at the way the camera could reproduce the world in all its magnificent detail. Through photographs they reveled in the experience of the everyday—of people, places, and things—as if they had never before seen the environment around them. The photograph quickly became prized for its capability to produce startling new images. Initially the shock was seeing the world itself represented. It was not long however, before the camera was used to locate surprising subjects or make the common subjects dramatic through isolation, unfamiliar vantage points, theatrical lighting, radical cropping, unusual juxtapositions, or any combination thereof.

By presenting an object from a strange and uncommon perspective, the photographer can call attention to a subject—as for example, in Imogen Cunningham's *Magnolia Blossom* (p. 53). Sometimes, the photographer renders viewers as voyeurs, enabling them to stare illicitly or at least giving them the impression that this is the case, as in Diane Arbus's *Puerto Rican woman with a beauty mark* (p. 63). In other cases, by contrast, the viewer is held at bay, offering an equally discomforting experience, as in Garry Winogrand's *New Mexico*, 1960 (p. 62). There are even those pictures, such as Robert Mapplethorpe's *Philip on a Pedestal* (p. 58), that beckon the viewer to examine the vulnerable-looking nude on the pedestal yet keep the viewer at a psychological distance by metamorphosizing the figure into a sculptural object. This dynamic—the effect of being drawn in and pushed away—makes one feel as if one has been manipulated. And, in fact, one has been. Because these pictures are photographs, we believe in the reality of their subjects. Yet, they are fictions calculated in the mind and eye of the photographer.

As with a good joke, what may make a photograph funny, surprising, or shocking is an implicit belief that it contains a grain of truth. Ironically, we often believe that the photographer is revealing the truth about a subject. However, what bestows a subject with drama is the photographer's point of view and editorialization. We, the viewers, are made to feel that we are a party to a conspiracy with the photographer. We are made privy to something that has been, or is about to be, disclosed. Hence, we may feel unsettled, disturbed, or seduced.

The strangeness of these photographs makes us question what we see. They are visual disruptions in our everyday habits of experience. They shake us loose from our conventions of seeing. As visual historian Simon Watney has pointed out, such defamiliarizing devices were used by Surrealist and Russian Constructivist photographers in the 1920s and '30s as a means of revolutionary, political intervention in an attempt to upset bourgeois views of the world. Photography's capacity "to make strange" as Watney called it, however, "is dissolved into the general Modernist need for constant stylistic innovation, seen as an end in itself."[1]

Nonetheless, to merely accept these photographs at face value is to misunderstand why each at the time of its own making "made something strange." What does the passing of time do to the way we see such photographs? Do we become inured to the novelty of all photographs? For example, one wonders if Margaret Bourke-White's glimmering close-up of irons, *Edison-Electric*, (p. 49) was even more spectacular at the time it was made? Is it now more of a quaint statement of Modern design?

What we must examine is the photographer's attitude about his or her subject. How did Diane Arbus see the Puerto Rican woman? As a defiant subject? Or as a monstrous other? What is the signification of Mapplethorpe's *Philip on a Pedestal*? What is Dan Graham's take on the planned community and tract houses that he presents in *Row of New Houses for Development, Jersey City* (p. 61)? We must also consider how a photograph is presented, and the verbal and pictorial company that it keeps. "Making something strange" is not only determined by the position of the lens but also by the location of the image in relation to other pictures and text. How does the context of a particular exhibition, book, article, or advertisement shift the way we understand a photograph? Formalists would no doubt find such questions of interest but, more likely, beside the point. They might even find that such information diminishes the pleasure of the pure aesthetic experience. On the contrary, understanding such things does not lessen the power of the picture. It helps us to appreciate the origins of that power and understand how it functions.

Edison Electric,
1930

"Industry is the true place for art today. Art should express the spirit of the people, and the heart of life
today is in the great industrial activities of the century. . . . It reflects the modern spirit of the world."

Margaret Bourke-White set up a freelance photography business soon after her graduation
from Cornell University in 1927. Her first professional job was photographing a steel
mill in Cleveland. Two images from that assignment, included in a juried exhibition, came
to the attention of publisher Henry R. Luce, who recruited Bourke-White to work for
Fortune magazine. The extended photo essays she did in the 1930s established her among
leading photojournalists. In 1936, she became one of the first photographers hired for *Life*
magazine, which premiered with her photographs of the Fort Peck Dam on the cover
and in the lead story. Bourke-White's ability to zero in on emblematic images, to give the
overall editorial message of a photo essay deeper meaning, set her apart, as can be seen
in the picture here. A phalanx of electric irons, which today seems a quaint reminder of
the past, was then symbolic of the technological leadership that would lead America out
of the Great Depression.

Margaret Bourke-White
American, 1904–1971

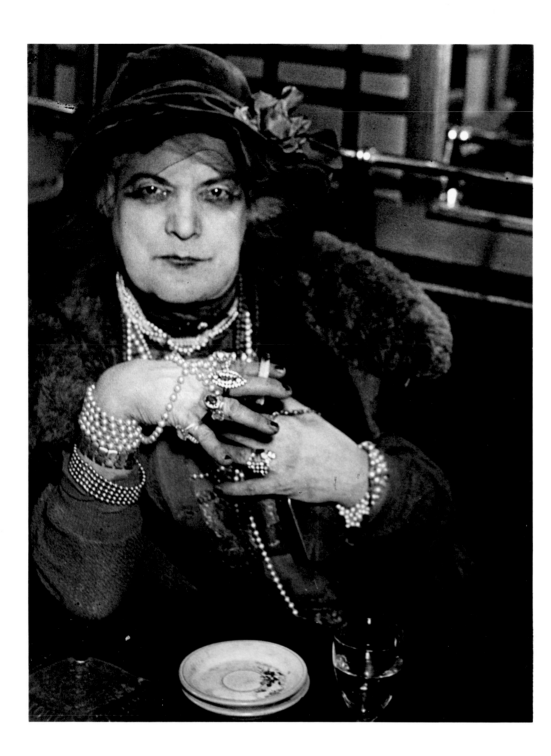

La Môme Bijou,
Paris, 1932

"I have never looked for subjects that are exotic or sensational in themselves. Most of the time
I have drawn my images from the daily life around me. I think that it is the most sincere and humble
appreciation of reality, the most everyday event that leads to the extraordinary."

Brassaï (Gyula Halász)

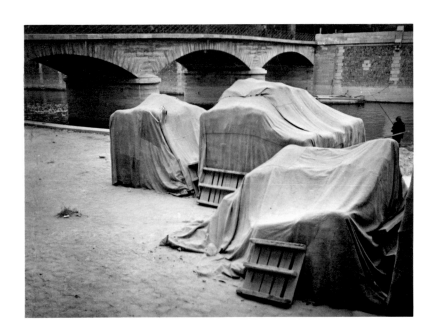

Behind Notre Dame,
1925

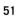

"Look at the atmosphere, the reflection. Why did I do it this way? Instinct. I have no other explanation.
The subject offered itself to me and I took advantage."

André Kertész

Havana Dock Worker,
1932

Walker Evans

"On an assignment, I would say to myself, you've got to do two things here. You've got to satisfy whoever is commissioning you—an editor—who thinks he is doing something that will interest the public, and then you've got to satisfy yourself, too, which is an entirely different thing."

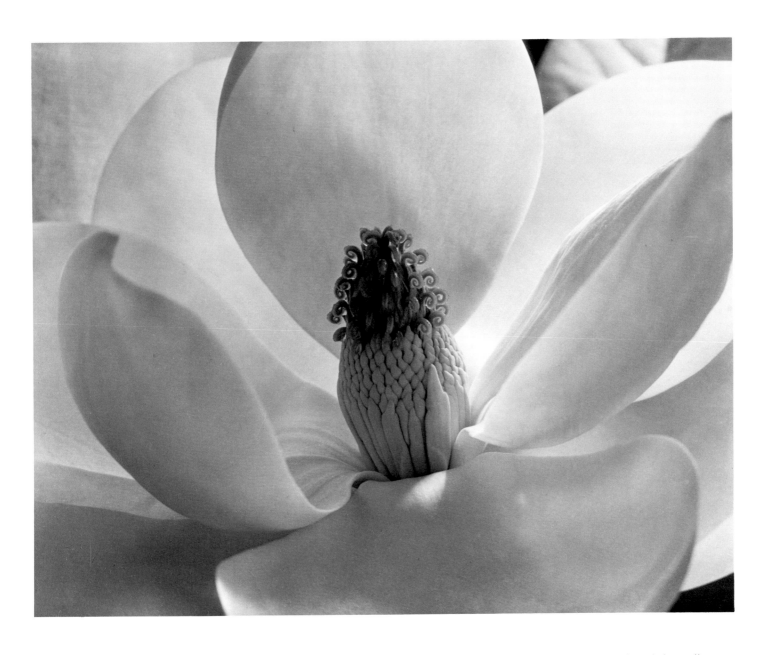

"One must not have a too-pronounced notion of what constitutes beauty in the external, and above all not to worship it. To worship beauty for its own sake is narrow and one surely cannot derive from it that aesthetic pleasure which comes from finding beauty in the commonest things."

During a career that spanned seven decades, Imogen Cunningham was greatly admired for her work, and for her pioneering role in the Modernist photography movement. In 1905, she began photographing while working as a darkroom assistant for Edward S. Curtis. Active in the West Coast photography scene, along with Edward Weston and Ansel Adams, Cunningham shaped an aesthetic in black-and-white camera work regarded today as classic. A series of extreme close-ups of plant forms, the first of which is reproduced above, brought her critical acclaim in the 1920s. Here, the qualities of a magnolia are revealed with the expansiveness usually found in great landscape photography. The variety and scope of Cunningham's work is less well-known, however, partly because she was active for so long. Her portraits of art-world and Hollywood luminaries, including Martha Graham, Theodore Roethke, and Cary Grant, also made Cunningham a much sought-after magazine photographer.

Imogen Cunningham
American, 1883–1976

Magnolia Blossom,
1925

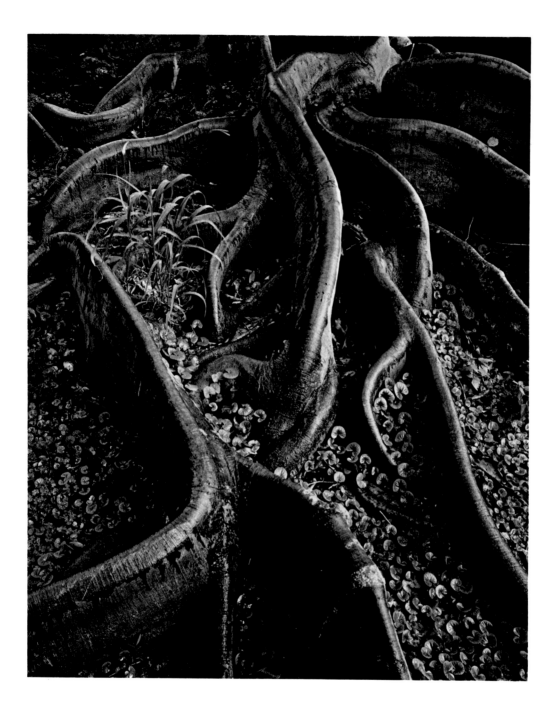

Roots, Foster Gardens, Honolulu, 1947

"To photograph truthfully and effectively is to see beneath the surfaces. . . . Impression is not enough. Design, style, technique—these too are not enough. Art must reach further than impressions or self-revelations."

Ansel Adams
American, 1902–1984

A spokesman for straight photography, an educator, conservationist, and writer as well, Ansel Adams achieved such great popularity that dealers often judge the strength of the photography market on sales of his most sought-after prints. Adams's uncompromising pursuit of aesthetic values and the technical perfection he brought to his work have had a significant impact on the acceptance of photography as an art form. *Moonrise, Hernandez, New Mexico* (frontispiece), the photograph that first brought Adams to prominence in 1941, demonstrates the effectiveness of his approach to previsualizing an image. From the time Adams sighted a subject and determined the lighting conditions appropriate for committing it to film, to the moment when he made the finished print, he applied painstaking judgment and rigor to his work. In the image here, highly descriptive through the perfection of Adams's craft, these snakelike, almost surreal roots present a darker, primordial vision of nature's hold on the imagination.

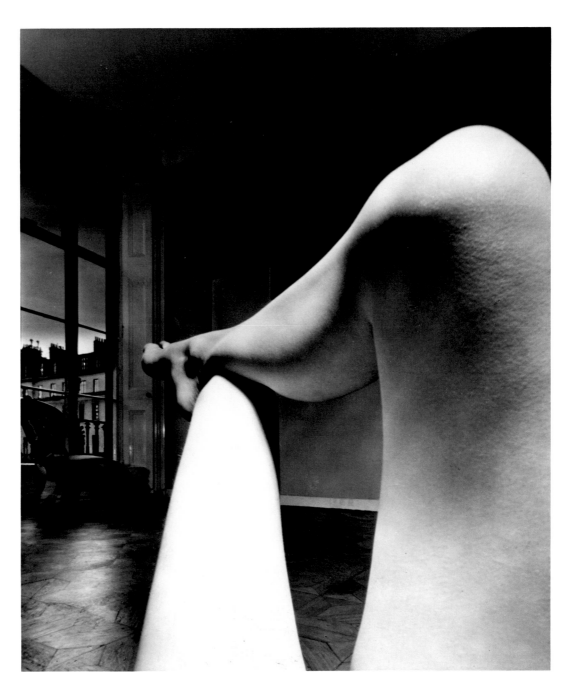

Belgravia, London,
1951

"I found *atmosphere* to be the spell that charged the commonplace with beauty. And still I am not sure what atmosphere is. . . . I only know it is a combination of elements, perhaps most simply and yet most inadequately described in terms of lighting and viewpoint, which reveal the subject as familiar and yet strange."

Bill Brandt
British, b. Germany, 1904–1983

In 1929, Bill Brandt began his photographic career in Paris as Man Ray's studio assistant, and counted Atget and Brassaï as his greatest influences. Brandt's early work was primarily documentary; during World War II, he was assigned by London's Home Office to photograph life in the city's bomb shelters. But his sense of "the spirit that charged the commonplace with beauty" imparted an edgy, psychologically ambiguous tension to his images. After the war, Brandt specialized in portraits of artists and writers for magazines while pursuing his personal projects—long-term photo essays for exhibition and publication in book form. For a series of nude studies in his 1961 book, *Perspective of Nudes*, Brandt used an antique wooden box camera. Its extremely wide-angle lens distorted the foreground and provided sharp focus from close up to infinity (as seen in the photograph reproduced here), which gives the image a mordant sense of romanticism bordering on the surreal.

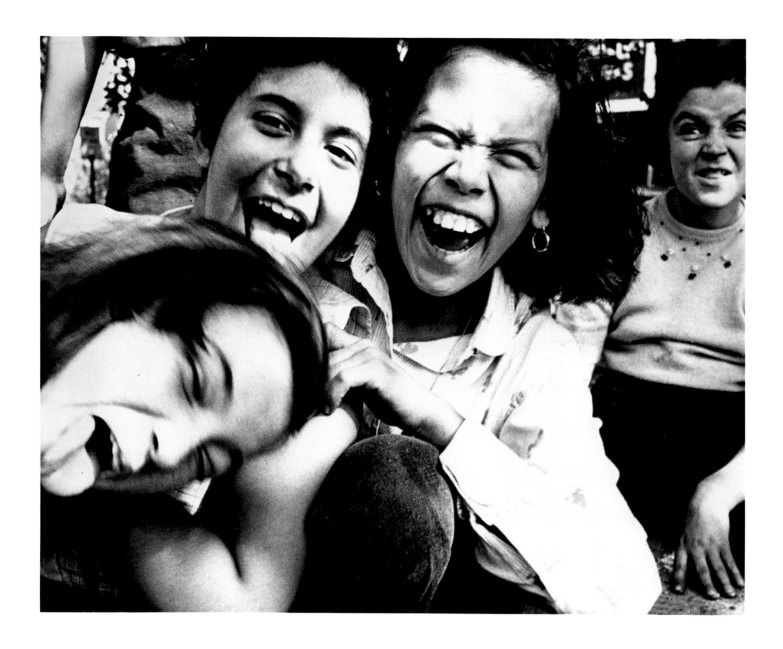

"The way the subject reacts to the camera can create a kind of happening. Why pretend the camera isn't there?. . . Maybe people will reveal themselves as violent or tender, crazed or beautiful. But in some way, they reveal who they are. They'll have taken a self-portrait."

William Klein
American, b. 1928

Four Girls + Laughs + Tongues,
New York, 1955

After studying painting on the GI bill in Paris, William Klein returned to his native New York, where he was offered a job photographing for *Vogue* in 1954. Although Klein did not take fashion seriously, the job gave him an opportunity to experiment freely and carte blanche lab privileges for his personal work. Klein created a highly charged, confrontational approach that made his subjects not only aware of his presence, but conspiratorial in the resulting images. Using a wide-angle lens, often at close range (as in the photograph here), Klein captured a sense of action bordering on the chaotic, that seemed to mock accepted standards of photo reportage. After moving to Paris in 1965 and publishing several books there, Klein abandoned photography for filmmaking. He became something of a cult figure in Europe, but it was not until 1980, when the Museum of Modern Art mounted a one-person show in New York, that his work was taken seriously by American critics.

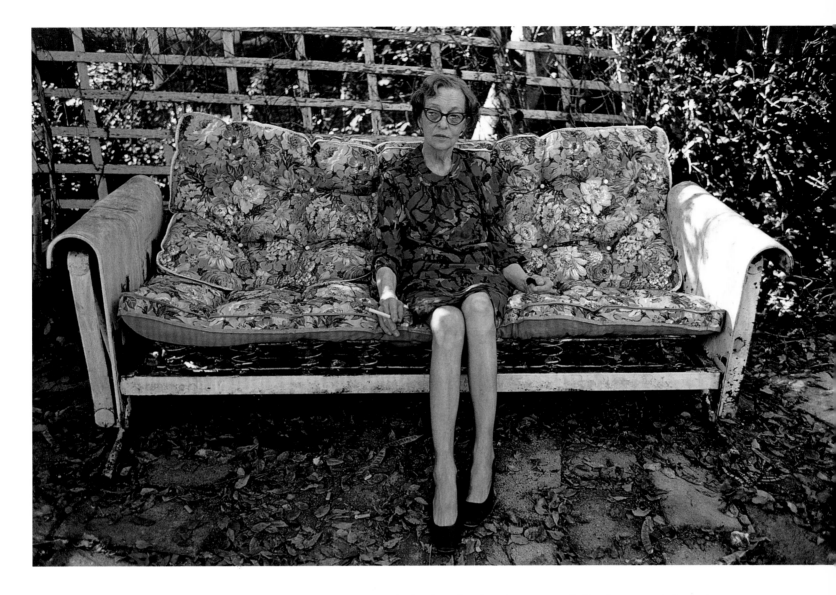

"I am afraid that there are more people than I can imagine who can go no further than appreciating a picture that is a rectangle with an object in the middle of it, which they can identify. They don't care what is around the object as long as nothing interferes with the object itself. . . . I am at war with the obvious."

When William Eggleston's color photographs were exhibited at New York's Museum of Modern Art in 1976, controversy erupted. His use of the dye-transfer printing method, through which he was able to alter hues and color-saturation levels, flew in the face of the prevailing Modernist credo. Curator John Szarkowski, however, heralded the collection as "the discovery of color photography." Many viewers and critics were also offended by their banal, if slightly decadent subject matter, and "amateurish" compositions. A close look at the photograph reproduced here offers an understanding of Eggleston's success working in a medium previously scorned by serious photographers. Cluttered with evidence of daily life's missed opportunities, the image isolates an instant that speaks intimately of the subject's persona. As Eudora Welty wrote, these pictures "succeed in showing us the grain of the present, like the cross-section of a tree. The photographs have cut it straight through the center."

William Eggleston
American, b. 1937

Jackson, Mississippi, 1972

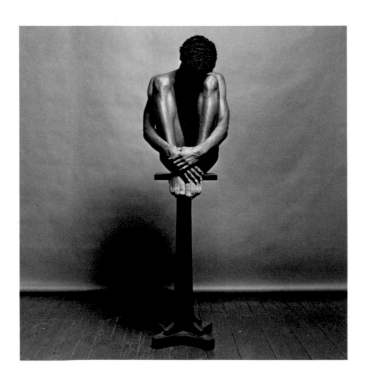 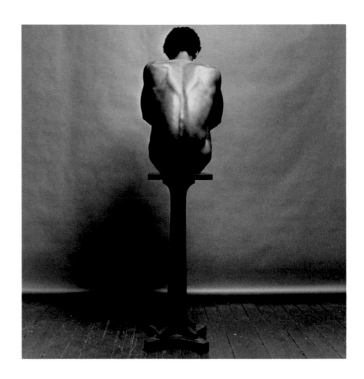

"I think the pictures I take dealing with sexuality are probably the most potent pictures that I have ever taken. They are the pictures that people remember more because they are unique. . . . They are more intense, though I don't think they're any more important than my other pictures."

Robert Mapplethorpe
American, 1947–1989

Philip on a Pedestal, 1979

Robert Mapplethorpe has said that when he settled on photography as his medium of choice, he knew nothing about its history. He brought to the work a way of choosing subjects that he'd formed through his experience as an underground filmmaker. Mapplethorpe took advantage, as Ingrid Sischy wrote, "of all the taboos and mysteries surrounding sex and homosexuality [to do] something that would be noticed." By the mid-1970s, his male and female nudes, and suggestive flower still lifes, were frequently exhibited. Mapplethorpe was also in demand as an editorial photographer, making celebrity portraits for magazines such as *Vanity Fair* and *Vogue*. The diptych above has the appeal that makes much of his work accessible to collectors of fine photography. Coolly composed and lighted, emotionally distanced through its pictorial flatness, the photographs indicate the camera's capacity for altering actuality. Here too, Mapplethorpe has reversed a common stereotype by placing a masculine object of desire on a pedestal.

"I have come to realize life as a coherent whole, and myself as a part, with rocks, trees, bones, cabbages, smokestacks, torsos, all interrelated, interdependent—each a symbol of the whole. And further, details of the parts have their own integrity, and through them the whole is indicated, so that a pebble becomes a mountain, a twig is seen as a tree."

At the age of sixteen, Edward Weston received his first camera as a gift from his father; from that moment on, Weston never shifted his gaze from the visible worlds he discovered through the ground glass of his viewfinder. He opened a portrait studio in what is now Glendale, California, and by 1927 had achieved critical and commercial success for portraits, landscapes, and nude studies that helped to change the perception of photography as a valid art form. Weston then began experimenting with extreme close-ups of vegetables and shells in which he banished scale and context, creating a condensed version of the object that pulsed with a visceral, sensuous energy, as seen in the image above. One of the most influential photographers of the twentieth century, Weston's genius lay in his ability to "recreate the subject in terms of its basic reality . . . in such a form that the spectator feels that he is seeing not just a symbol for the object, but the thing itself revealed for the first time. . . ."

Edward Weston
American, 1886–1958

Cabbage Leaf, 1931

Cotto, 1970

"My father told me about a wrestling match he had seen the year before I was born where one of the wrestlers threw [the other one] completely out of the ring. . . . My father said it was a good thing I wasn't around then because the wrestler landed . . . where I might have been sitting had I been born a year or more earlier."

William Wegman
American, b. 1942

Seemingly irrelevant to photography, the quote above shares the surrealistic irony of William Wegman's early work in the medium. Struggling to find a voice when process art (which relied on photography to document activity staged exclusively for the lens) was flourishing, Wegman used the camera to record visual evidence of his off-center ideas. Employing a modicum of technical finesse, they also cut through the seriousness and lack of humor in prevailing art trends. Wegman has said that the photograph here was "the picture which proved to be the answer and the way out" of his dilemma as an artist. Working in black and white, he went on to explore the irrationality and uncertainty of physical realities and soon engaged his pet dog, Man Ray, as an actor in those hermetic dramas. His work in photography, video, and painting often has the engaging wit of a joke or cartoon—rudimentary constructs that quickly draw the viewer in, then celebrate the exchange with laughter.

"I have been asked recently if I would make work using virtual reality technology. I think that my work has been situated in that area of the cinematic, hallucinatory, kaleidoscopic, which virtual reality will now fill . . . so maybe virtual reality will lend itself to the next development in my work."

Dan Graham creates cultural meaning in various media from still photography to written texts, architectural constructions, performance, and video. His early pieces from the 1960s were critical of the ways in which an artist's work was accorded the status of "art." Running a gallery, Graham realized that his own work would be published and reviewed by art magazines if he bought advertising space. Graham has said that because art value was linked to the reproduction of art, he thought it would be interesting to bypass the gallery system and simply "place" his images in magazines, along with a text, for the cost of an ad. In effect, Graham created a disposable form of Pop art meant to be viewed as printed matter and treated likewise. Seen out of context, the photograph above loses its original meaning. But Graham's vision of prefab houses, lined up like so many cans of soup, can still be appreciated as a dramatic transformation of subject matter seen through the eye of an artist.

Dan Graham
American, b. 1942

Row of New Houses
for Development,
Jersey City, NJ, 1966

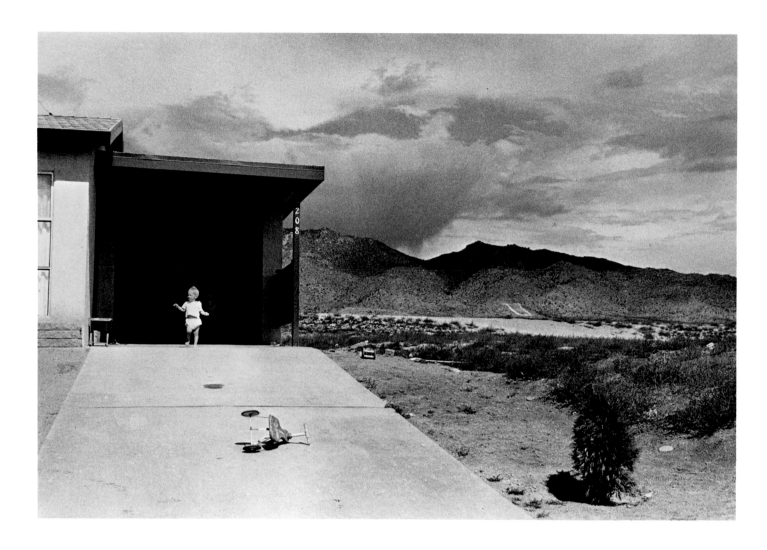

"There is nothing as mysterious as a fact clearly described. . . . I photograph to find out what the world looks like photographed."

Garry Winogrand
American, 1928–1984

Albuquerque,
NM, 1960

Often placed within the "social landscape school," Garry Winogrand's photographs turned current ideas about documentary photography literally on edge when his work appeared in exhibitions during the 1960s. Self-taught, with Walker Evans' book *American Photographs* as his sole reference to the history of the medium, Winogrand operated through a visceral response to situations he encountered. Visually expansive, yet confined to their author's emotional range, the subjects were often framed on an angle and studded with extraneous detail. Winogrand adopted the motor drive, using his camera like a machine gun to capture slight shifts in movement and angle of view. To his critics, these photographs seemed too chaotic, too personal, too raw. The image here intimates signatures of Winogrand's mature style. In a slightly off-kilter frame, a child engaged in no particular activity before a banal suburban house becomes an elemental figure of life through the majestic landscape and the stately blackness of the garage.

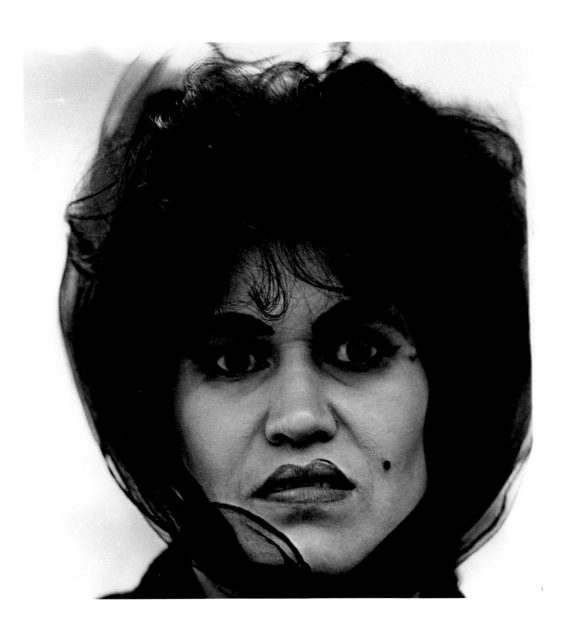

Puerto Rican woman
with a beauty mark, NYC,
1965

"For me the subject of the picture is always more important than the picture. And more complicated.
I do have a feeling for the print but I don't have a holy feeling for it. I really think what it is, is what it's
about. I mean it has to be of something. And what it's of is always more remarkable than what it is."

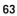

After having established herself as a freelance magazine photographer in the early 1960s,
Diane Arbus began producing the body of work for which she has become known.
Through portraits she made of people on the margins of society, Arbus sought to reveal
an emotional landscape that casual observers would likely avoid. Unaffectedly composed,
often harshly lighted, these images expose realities without artifice and, in the process,
show what the world can offer those who look without casting judgment. In a conversation
with John Szarkowski of New York's Museum of Modern Art, Arbus once said that a
photograph of two people in bed is shocking because a photograph is private, whereas a
movie showing two people in bed is not shocking because a movie is public. The sense of
that statement is apparent in the confrontational portrait above, which engages the viewer
in an unsettling meeting with someone the photographer found fascinating.

Diane Arbus
American, 1923–1971

4 The Divided Self

Photography has often been considered a medium of self-discovery. It is, perhaps, with pictures of people that the idea of self-realization is most frequently raised. For the defining of oneself is in relation to others, as well as to oneself. It is a common idea that a photographer's profound and intuitive understanding of the medium may enable him or her to reveal core truths about someone. This notion is based on the concept that individual identity is singular, stable, and therefore knowable. Many photographs do seem to reveal unexpected insights into a subject, making us feel as if we have glimpsed the soul of a sitter. What photography actually reveals are the many facets of self. Edward Weston's forceful *Portrait of Tina Modotti* (p. 67) suggests someone caught off-guard with a hand raised in a self-protective gesture. We have been made to feel as if the photographer, and therefore, we, have violated her privacy. The image is confrontational. We must ask, to what extent is this photograph a performance? Weston made dozens of pictures of Modotti from 1923 to 1926 (in Mexico). Therefore, Modotti functioned as a model rehearsing her emotions before the camera, adapting to the needs and expectations of the photographer. This fact, coupled with the pathos and intensity of the image itself, is even more disconcerting. Instead of penetrating the layers of self, the image reveals more layers. What, if anything, photographs teach us is of our inability to fully know ourselves or others.

The conditions of modern life are such that individuals are often alienated and disconnected from themselves and other people. Street photographers have long made revelatory, candid portraiture the subject of their work. In an image such as Louis Faurer's *Eddie* (p. 75), the subject seems vulnerable and almost pitiful. But the key word here is *seems*. Perhaps he is, but what do we really know about the subject? This uncertainty adds to our own uncertain feelings and knowledge about the subject. Louis Stettner's *Penn Station* (p. 74) captures three people reading the newspaper. In the background, we see a partial view of someone holding a paper. That person is obscured by the man in the middleground who is doing the same. On the extreme right foreground, a figure almost completely cropped out of the image by the frame also holds a newspaper. The implication here is that we too are part of this scene. We too are but a face in the crowd. Yet behind each face is a life. The sense of alienation is conveyed, but we must be cognizant that Stettner's picture is a symbolic generalization.

In other works, the suggestion is that we see ourselves as others see us. In Robert Frank's *Mary* (p. 65) the shadow, presumably of the photographer, partially covers the subject's face. She returns the photographer's stare, as if to say, "I look at you as I know you look at me."

This consciousness, that the self is constructed by the other, the one who looks and takes the picture, becomes even more pointed in those staged, post-Modern images such as Cindy Sherman's *Film Still #53* (p. 79), in which she constructs herself as a young woman seen through the eyes of the worlds of fashion, Hollywood, and advertising. Or, in Sarah Charlesworth's highly disturbing diptych *Objects of Desire* (p. 76). On the left, a woman is helplessly bound, S&M–style, against a slick-looking, blood-red backdrop. On the right an empty, fashionable, floor-length dress is posed in an alluring, suggestive manner. This picture, which emulates the fetishism of fashion photography, addresses the way "the feminine" is constructed by the male-dominated media. We are all increasingly the visual projections of what advertising, television, and Hollywood want us to be—women in particular. Such images deny personal revelation as the purpose of photography. Charlesworth's picture artfully reveals the contradictions inherent to the medium of photography: we expect it to tell the truth when in fact it disguises and manipulates what is real.

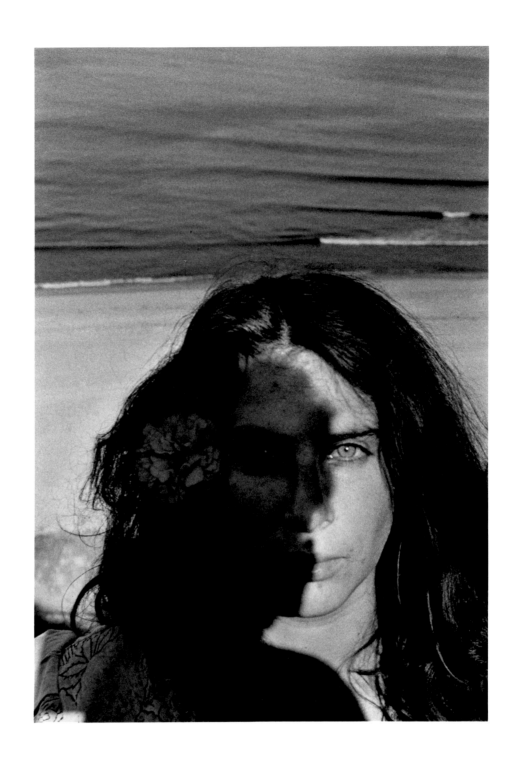

Mary, 1954

"Black and white is the vision of hope and despair. This is what I want in my photographs."

Robert Frank

"I began as a painter. In photographing my canvases I discovered the value of reproduction in black and white. The day came when I destroyed the painting and kept the reproduction. From then on I never stopped believing that painting is an obsolete form of expression and that photography will dethrone it when the public is visually educated."

**Man Ray
(Emanuel Rudnitsky)**
American, 1890–1976

Untitled, 1931

When Man Ray moved from New York to Paris in 1921, he was introduced by his friend Marcel Duchamp to the avant-garde circle of artists, writers, and poets which included André Breton, Francis Picabia, and Tristan Tzara. Working as a portrait and fashion photographer gave Man Ray the means to pursue experimental work in the medium, through which he strove to upset bourgeois concepts of beauty, the anecdotal, and the rational. First with cameraless images he called "Rayographs," later with his solarized portraits (both of which originated as darkroom accidents), he made visible Surrealist theories of automatism and chance. He moved fluidly between the fields of art and commerce, photography, painting, and filmmaking, always puzzled by the distinction American critics then made between high and low art. For Man Ray, who said, "No plastic expression can ever be more than the residue of an experience," there were no borders delineating work and life.

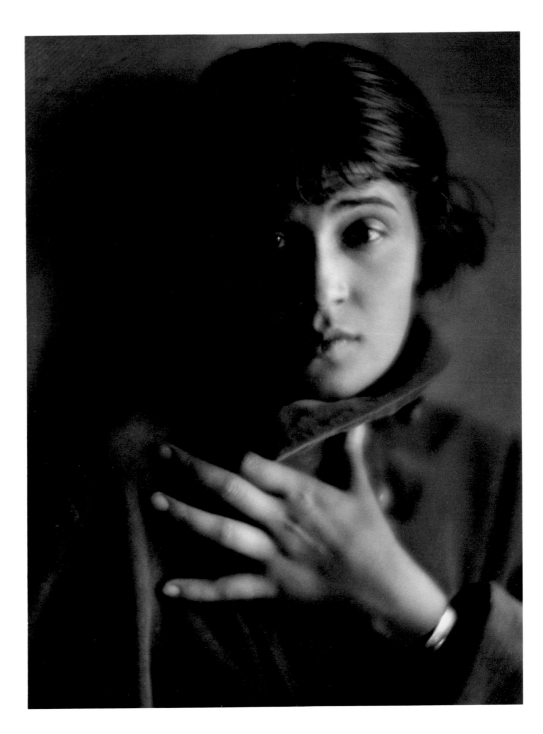

Portrait of Tina Modotti,
Glendale, 1921

"My birthday morning. . . . From Tina . . . most loved of all by me, a letter, a note of two words and three purple hyacinth buds which conveyed more in simple emotion than pages could have done. The words were only 'Edward, Edward!' "

Edward Weston

68

"Having been torn from my homeland during my adolescence, I am overwhelmed by the feeling of having been cast from the womb. My art is the way I re-establish the bonds that unite me to the universe."

Ana Mendieta
Cuban, 1948–1986

Corazon, 1975

At the age of thirteen, Ana Mendieta was exiled from Cuba to America, where she lived in a foster home until she enrolled in the University of Iowa. In the art-school atmosphere of the early 1970s, when painting had been pronounced dead, and the fine arts were being redefined as the visual arts, Mendieta gravitated to performance and body art. The idea of fragmentation, one of the markers of post-Modern thought, had an expansive effect on her work, in the sense that one medium (or fragment) is as valid as another. Mendieta used elemental materials—earth, water, fire, blood, and bone—to carve, mold, dig, paint, and burn images of a universal feminine being. Using both video and still photography, she recorded their visual manifestations, thereby becoming the objective documentarian of her subjective experience as an artist. The image here is one of the early works in which Mendieta began creating an abstracted vocabulary of feminine forms.

Double Portrait, 1930

Born in 1906 in Marchiennes, France, Jean Moral began photographing during the 1920s, taking candid street photos and also experimenting with darkroom techniques such as photograms and solarized images. His wife Juliette became his favorite model, and his photographs of her—of a liberated woman, happy, active, and intelligent—first published in *Paris Magazine*, reveal the new way of life that emerged in Europe between the wars. In 1932, Moral photographed briefly for *Vogue* under the direction of Michel de Brunhoff, after which he worked for *Harper's Bazaar* until 1952. His fashion photos, in the same spirit as his earlier studies of women, are spontaneous and dynamic, often shot in busy streets surrounded by advertising billboards and other symbols of the modern era. Moral published and exhibited his work regularly until the 1950s, when, on the advice of painter Francis Picabia, he gave up photography for drawing and painting.

Jean Moral
French, b. 1906

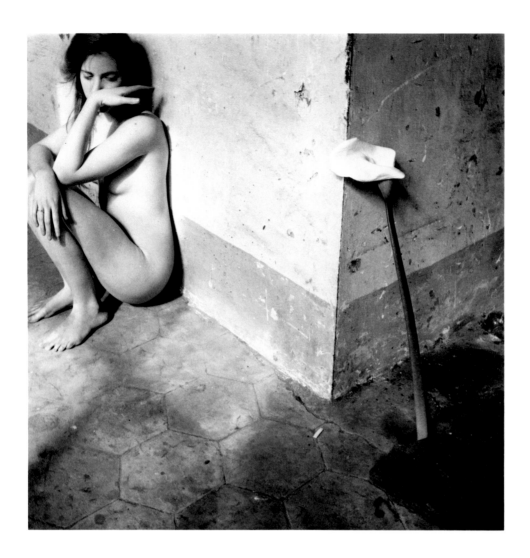

Untitled, no date

"It is my image that I want to multiply, but not out of narcissism or megalomania, as could all too easily be believed: on the contrary, I want to conceal in the midst of so many illusory ghosts of myself, the true me, who makes them move."
—Italo Calvino

Francesca Woodman
American, 1958–1981

A look at the small percentage of Francesca Woodman's 500 or so images that have been published offers a compelling view of a protean young artist who took her life at age twenty-two. Woodman's subject was her own body, often nude, sometimes in combination with other nude females who could be her doubles. In highly orchestrated images that play on photography's natural surrealism, Woodman explored such visual and nonvisual phenomena as verticality, horizontality, weightlessness, space, and time. Those subjects were sometimes student assignments, which Woodman often expanded on during summer visits to her family's Italian villa. Kathryn Hixson has written that a "combination of romantic fantasy within very physical classical depictions of the body in space . . . characterize the strength of her work. Woodman's personal vision expands the photographic medium . . . for its magic, its ability to represent reality, and its manipulated reflection of that reality."

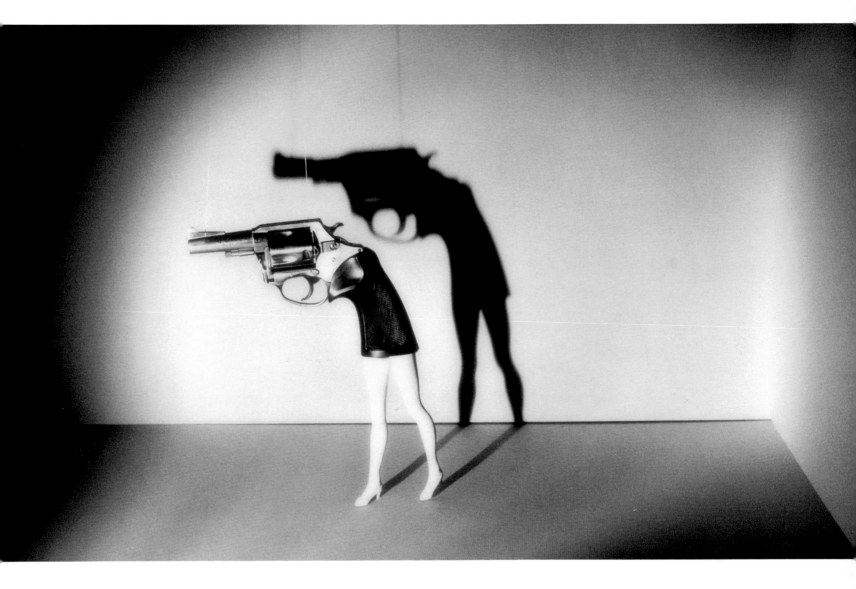

Walking Gun, 1991

"I'm making work about memory. And not my own personal autobiographical memory, but more like an exploration of memory and history. It's not an exorcism of the past, but rather as an honest point to begin an external dialogue."

Social identity and gender representation have been pervasive themes in post-Modern visual arts, offering a platform for political as well as aesthetic dialogue. A consistent voice in this arena has been Laurie Simmons, whose metaphorical characters in the "Walking Objects" series indicate the extent to which women have been diminished by their identification by corporate cultures with consumer products. Objects of commercial value (an alligator handbag, a suburban ranch house, for example) are grafted onto the alluring legs of female dolls. These slightly ridiculous surrogates are photographed in stagelike settings, dancing, curtsying, or laid down as in sexual offering. In one, the human legs of a man support a camera that aims and shoots at its female cohorts: a humorous, if bleak commentary by Simmons on the role photography has played in the fetishizing of women. The images are presented as mural-sized prints whose large scale and technical refinement intensify Simmons' disquieting message.

Laurie Simmons
American, b. 1949

"most days I thINk I'D RATher be a PHOTograPH than a huMAN BeIng."

Jack Pierson
American, b. 1960

Still from
"The Celestial Child,"
1993

Media saturation and investing the mundane with beauty are discernable preoccupations among visual artists turning away from post-Modernism's theoretical precision. Among them is Jack Pierson, who has said that as an art student he "wanted to be a filmmaker or design theater posters, or direct Pinter: I wanted color Xerox to be my only medium one day, to only do 'performance art' the next." Giving in to ambivalence proved to be fruitful; his work variously takes the form of installations that combine photographs, works on paper, 3-D messages, reconstructed interiors complete with debris, and single photographic images like the one reproduced here. Adopting the authorless quality seen in many amateur snapshots, Pierson transmutes everyday episodes through the use of color copiers and commercial printing methods. In his diaristic visual narratives, Pierson brings "little triumphs of the real" to themes of loneliness and desire.

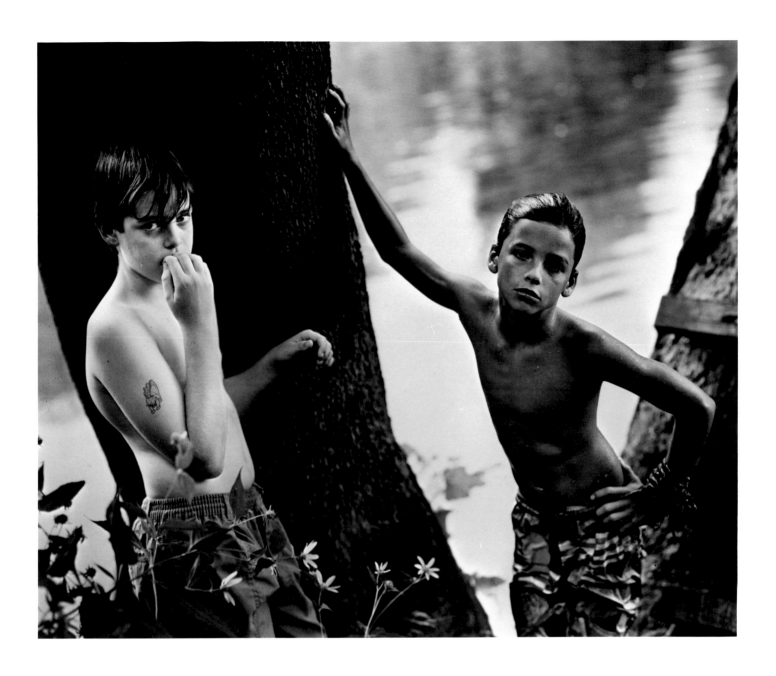

"For me, [the] pointed lessons of impermanence are softened by the unchanging scape of my life, the durable realities. This conflict produces an odd kind of vitality, just as the madman's despair reveals a beguiling discovery. I find contained within the vertiginous deceit of time its vexing opportunities and sweet human persistence."

Set in the lush countryside of her summer cabin in Virginia, Sally Mann's photographs from the series entitled "Immediate Family" (1992) chronicle her three children's passage from childhood dependence to emotional self-sufficiency. Moments of spontaneous rapture are interspersed with scenes set up especially for the camera. Mann often trains her lens on episodes that inspire fear for a child's safety: a black eye, hundreds of nasty insect bites, Popsicle drips on a naked torso that resemble trickles of blood. These small everyday dramas are magnified by the way in which Mann uses the camera to at once heighten and shift meanings. Through selective focus, the Edenic landscape becomes a menacing presence, magnifying the emotional pitch and utter impermanence of the moment captured. As in the photograph here, a child's innate sexuality is naturally stated, dispelling convenient myths about childhood's innocence.

Sally Mann
American, b. 1951

Emmett and the White Boy, 1990

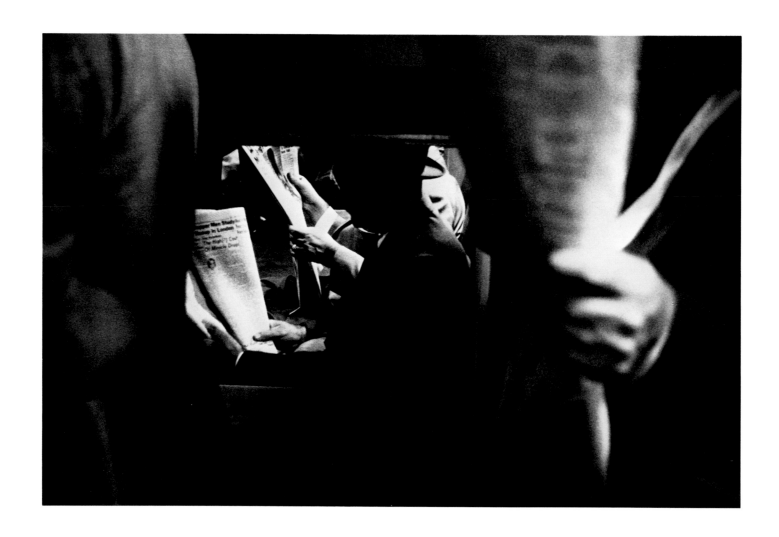

"Photography has always been to me a passionate way of interpreting the world around me. Human beings (whether they are in the photograph or not) have always been the central theme of my work."

Louis Stettner
American, b. 1922

Penn Station, ca. 1958

In straight photography, an approach that assumes the camera naturally offers windows on reality, it is the photographer's constant challenge to find new ways to penetrate the surface of things. The picture here by Louis Stettner—whose career includes editorial work for magazines (including *National Geographic*, *Time*, and *Fortune*) as well as personal projects for books and exhibitions—illustrates the way in which he made an everyday experience dynamic and memorable. Visually complex, layered in light and shadow, this view into a crowded commuter train becomes panoramic through the close, wide-angle view. By surrounding the activity in darkness, Stettner gets rid of the camera's frame, in effect, bringing the viewer into the picture. An expression of alienation at first glance, the photograph invites viewers to search for signs of individuality amid sameness.

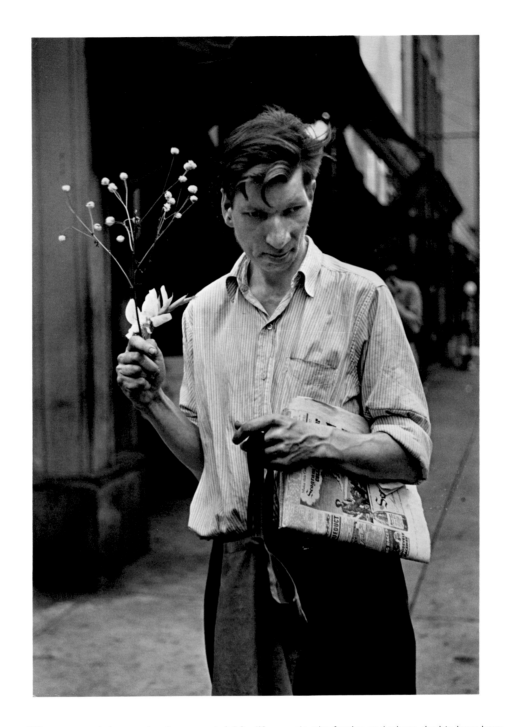

Eddie, 1946

"My eyes search for people who are grateful for life, people who forgive and whose doubts have been removed, who understand the truth, whose enduring spirit is bathed by such piercing white light as to provide their present and future with hope."

Louis Faurer had an active freelance career in New York from 1947 to 1969, photographing for fashion magazines and for *Fortune*. At *Harper's Bazaar*, Faurer formed a lasting friendship with Robert Frank, whose darkroom he shared. Although Faurer's work had appeared in important exhibitions, wider recognition of his intensely personal street photographs did not come until the late 1970s. Walter Hopps of New York's Museum of Modern Art wrote, "The city is Faurer's natural habitat. He can be at home, at one, with people on its streets, in its rooms. . . . And since these people are extremely varied, it is a transcendent vision that allows the photographer to be so many 'others.'" In the photograph here, Faurer creates a fictional world as sharply fixed in time as the defining moment in a Shakespearean tragedy, suggesting a before and after in his subject's life.

Louis Faurer
American, b. 1916

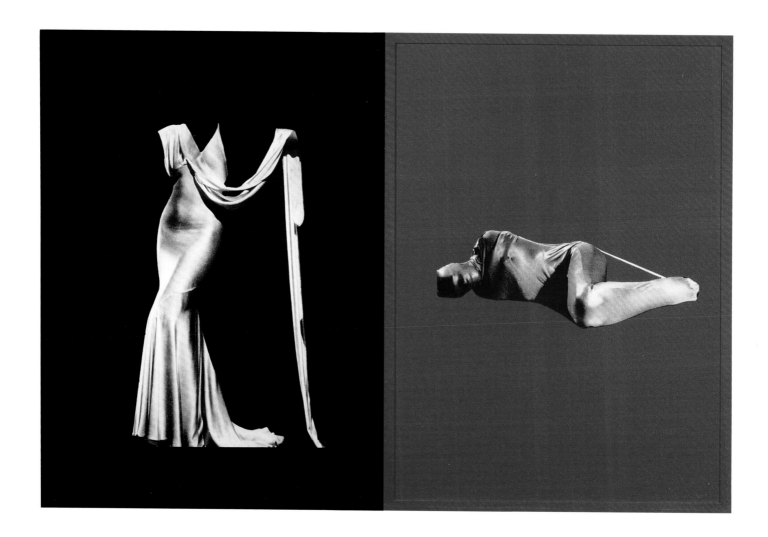

"The arrangement of images . . . allow[s] for the condition of multiple interpretations. The viewer completes the act of interpretation. . . . It allows even contradictory interpretations. It doesn't resolve things. There's no closure in these."

Sarah Charlesworth
American, b. 1947

Objects of Desire,
1983

Sarah Charlesworth first used photography to fulfill her senior art history thesis at Barnard College, New York, creating a study of the Guggenheim Museum in lieu of a written paper. She later supported herself as a freelance photographer while making art that explored cultural manipulations she observed in the mass media. In the early 1980s, Charlesworth found an intellectual kinship with other artists (including Laurie Simmons and Cindy Sherman) who used photography to investigate representation. By then she had begun a series based on the premise that history is constructed through reproduced images. In "Objects of Desire," Charlesworth reveals how meanings can be formed, then altered, through juxtapositions of photographs that originated in other media, primarily fashion magazines. Collaged, rephotographed with backgrounds of saturated color, and executed as vibrant, glossy dye-destruction prints, these technically exquisite images also toy with the viewer's perception of them as objects to desire.

Pierrot,
1922

"Whereas we do not find it hard to accept the beauty of a flower for itself alone, in present-day, mechanical-industrial civilization, people will usually question the use of a picture. Things are estimated much more for what they do or will do than for what they are or will become. . . . "

In his lifetime, Paul Outerbridge was known for the avant-garde fashion and still-life photography he created for *Vogue*, *Vanity Fair*, and *Harper's Bazaar*. Taking up the medium in 1921, Outerbridge quickly mastered the painstaking platinum-printing process. Like the image here (reproduced at actual size), his published work had abstract qualities that were heightened by their technical perfection. His friendship with Man Ray during the 1920s prompted Outerbridge to pursue new techniques for making photographic images; he then perfected the elaborate and costly multiple-negative, carbro color-printing process. Through a pattern of obsessive and diffident behavior, however, Outerbridge brought a successful career to a standstill and was virtually unknown at the time of his death. In recent years, the fetishistically posed nudes he created, at the same time he was turning out pristine images for magazines, have spurred a reexamination of Outerbridge's influence on contemporary photography.

Paul Outerbridge
American, 1896–1958

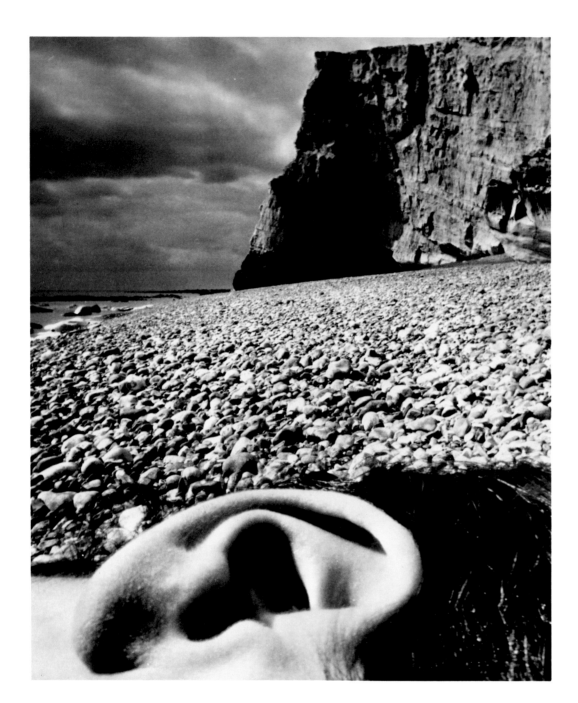

East Sussex
Coast, 1957

Bill Brandt "It is part of the photographer's job to see more intensely than most people do. He must have and keep in
him something of the receptiveness of the child who looks at the world for the first time or of the traveler
who enters a strange country."

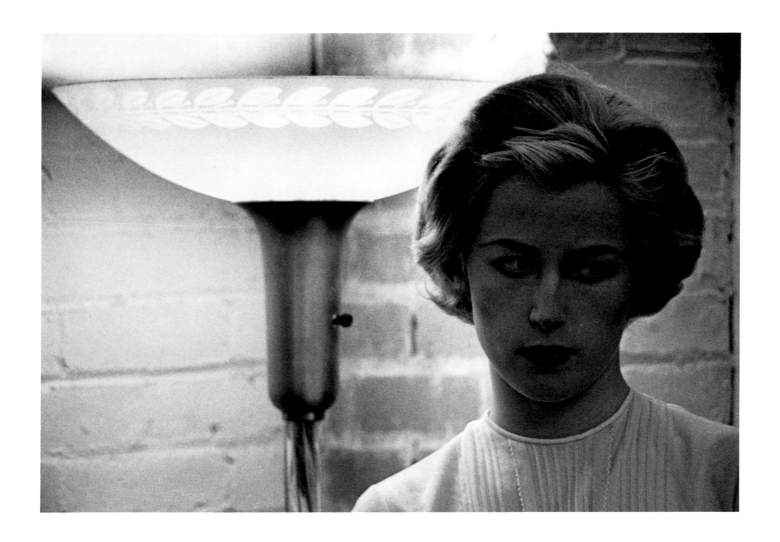

"When I prepare each character I have to consider what I'm working against; that people are going to look under the makeup and wigs for that common denominator, the recognizable. I'm trying to make other people recognize something of themselves rather than me."

When Cindy Sherman's "Film Stills" were first exhibited in 1977, the New York art scene received a regenerative jolt. In these set-up images based on 1950s Hollywood B-movie publicity photos, Sherman played author, director, set designer, and actor. As photographs, they were technically flawed. They also risked being appreciated for their roguish comedy, but Sherman's work was critically received as original, astute commentary on the stereotyping of women in art and society. Over the next decade, Sherman extended her use of the mask, working in lurid color, creating increasingly elaborate sets and gender-bending costumes for surrealistic tableaux so densely layered with information the artist virtually disappears. Conceived as photographs but orchestrated with cinematic exactness, these images usurp the role traditionally held by large-scale narrative paintings. Ingrid Sischy describes Sherman's "dramas" as "a primal battle over control . . . an archaic fight, both pre- and post-Modern."

Cindy Sherman
American, b. 1954

Film Still #53,
1980

5 Telling Tales

John Szarkowski wrote in *The Photographer's Eye* that "photography has never been successful at narrative. It has in fact seldom attempted it." While it may be true that a photograph without words does not tell a complete story, photography was linked historically to narrative more frequently and successfully than Szarkowski would like to acknowledge. For example, there is an extensive tradition of narrative photography in nineteenth-century family albums, and in the ubiquitous stereo-photograph travelogues and drama series that were a fixture of many a Victorian parlor. Szarkowski's aesthetic approach necessitated severing an image from extraneous information outside "the frame," and for the most part, not tampering with what is inside it, say through handwork or photomontage. As theorist and photographer Allan Sekula has written, "Every photographic image is a sign, above all, of someone's investment in the sending of a message."[1] How that message is understood, no less created, is a complex issue and the subject of much theoretical discussion. Not only is it based on the context in which a picture is presented, but also on the cultural assumptions and personal associations one brings to an image.

In a photograph such as Eugene Smith's *Soldier with Canteen, World War II*, 1944 (p. 82) one might assume, in the absence of a caption, that this image makes a heroic statement about war in general or the American participation in World War II in particular. If one knows of the photographer's outspoken liberal politics, one might interpret it as a critique of war. If the same picture was viewed by an American soldier who had been in Saipan in June of 1944 it would no doubt stimulate another reading. Or, if seen by a former Japanese soldier, yet another. This is not to say that the photographer does not have a story or several stories to tell. He did. In fact, he wrote at the time, "every film that I exposed was from my heart, in the bitter condemnation of war."[2] However, given the context of the other images that accompanied this one in *Life* magazine, it told yet another story, a story not as strident as Smith's words would suggest. As this example indicates, a photograph has many determining factors that shape its reading.

A photographer such as Lewis Hine largely believed in the truth-telling capacity of a photograph such as "*On the Hoist," Empire State Building* (p. 83). He wrote, a picture "is a symbol that brings one immediately into close touch with reality." It tells "a story packed into the most condensed vital form."[3] Although he was cognizant that photography was malleable, he essentially believed that the medium told the truth. His well-known adage was, "While photographs may not lie, liars may photograph." Many contemporary photographers also acknowledge and use photography's fragmentary suggestiveness and malleability to their advantage. However, for them, it is understood that the photograph can and *does* lie and only reveals part of the story.

Carrie Mae Weems was variously trained in art, photography, and folklore. In her work she often uses the language of documentary photography, which she purposefully subverts and complicates through artistic license and the admixture of historical source materials. Weems understands that the language of documentary photography is a construct and is based on the belief in the photograph as evidence. Yet, by using the appearance and code of documentary photography, she can weave image and text, fact and fiction, to reveal humanistic insights. She understands that "'lies' and fictions have a lot of truth to tell."[4]

The texts in her triptych *Untitled* (From the "Sea Islands" series) (p. 88–89) were selected and structured by the artist from historical sources, and include legends, sayings, and other lore. Some of the photographs were made on site, others are staged. The stories she tells are multiple, partial, and incomplete. They are part history, part myth. They exist in the present but recall the past.

A photograph can be like a snippet of conversation heard while eavesdropping. What can one surmise from a fragment of conversation not knowing what preceded or succeeded it? What can one gleen about the speakers? Their values? Their ideas? A definitive reading is not possible. It is contingent on too many assumptions.

Weems, like other artists of her generation, does not deny us the possibility of weaving tales from her photographs and texts, but alerts us to the fact that it is ultimately the viewer who is doing the weaving. Photographers use the signs, the language of their art to lead us down certain paths which, as they know, we may or may not follow.

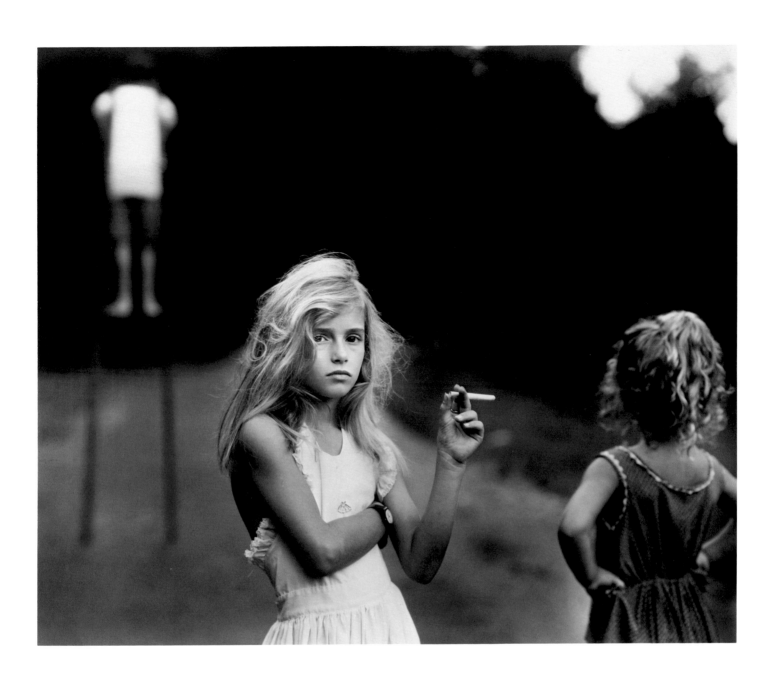

"This culture holds a somewhat dismissive and at the same time idealizing attitude toward children. As a consequence, images of empowered children are often alarming."

Sally Mann

Candy Cigarette,
1989

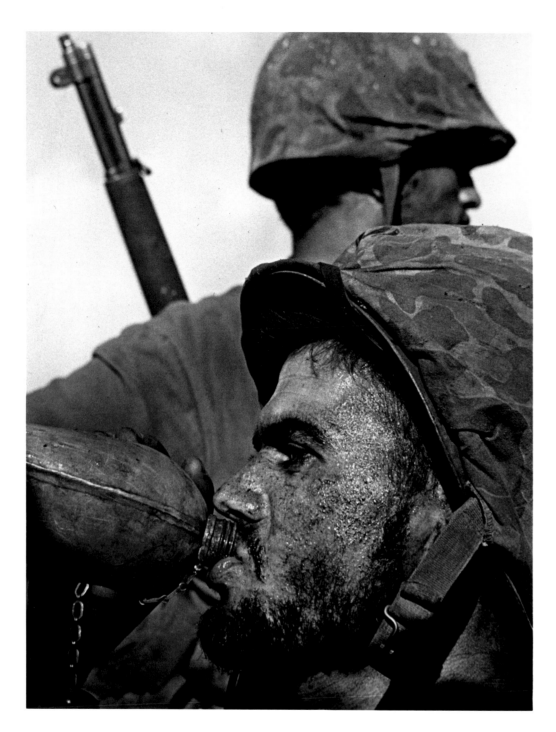

Soldier with Canteen,
World War II, 1944

82

"World War II . . . and each time I pressed the shutter release it was a shouted condemnation hurled with
the hope that the pictures might survive through the years, with the hope that they might echo through the
minds of men in the future—causing them caution and remembrance and realization."

W. Eugene Smith
American, 1918–1978

In the public mind, W. Eugene Smith has been identified with concerned social photography through his coverage of World War II and his photo essays for *Life* magazine. Smith began taking pictures as a child; during his high school years, he was photographing for the local Wichita newspapers. When *Life* started up in 1937, Smith headed for New York and within two years had signed on with the magazine. Smith brought a high sense of moral purpose to his work, which was often frustrated by the magazine's need to publish every week according to a strictly defined editorial mission. Twice he resigned over disagreements with editors. But through his published photo essays, Smith instilled the art and the business of photojournalism with integrity.

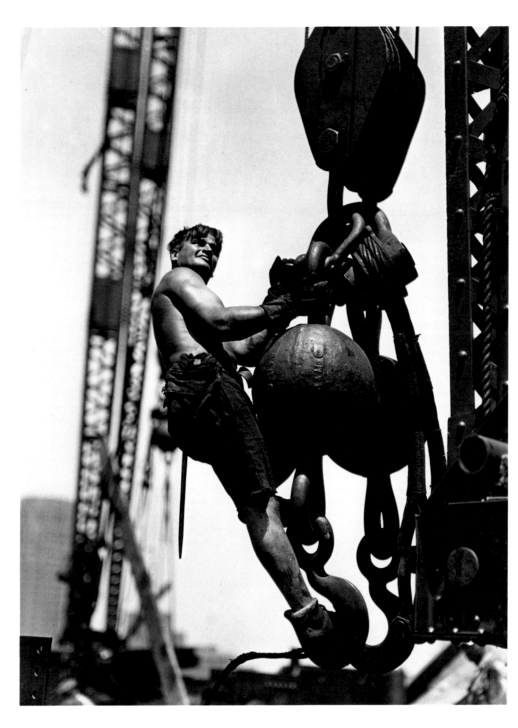

"On the Hoist,"
Empire State Buiding,
1931

"The photograph has an added realism of its own. . . . For this reason the average person believes implicitly that photography cannot falsify. Of course, you and I know that this unbounded faith in the integrity of the photograph is often rudely shaken, for, while photographs may not lie, liars may photograph."

When Lewis Hine became a freelance photographer in 1908, he first used the medium to expose intolerable conditions in the workplace. Hine's direct and compelling images championed the dignity of workers and brought public attention to the need for labor reform. Between the wars, Hine focused his attention on the machinists, stevedores, and construction workers of the Industrial Age. The image here originally appeared in *Men at Work*, published by the builders of the Empire State Building in 1932. Celebrating the worker as heroic figure through its dynamic viewpoint and dramatic light and shadow, the image transcends fact of record. While Hine set out to change the world through social reform, his sharp insight has had a lasting imprint on photography's power to illuminate and persuade.

Lewis Hine
American, 1874–1940

84

Robert Frank

Fear/No Fear, 1991

"The truth is the way to reveal something about your life, your thoughts, where you stand. It doesn't just stand there alone, the truth. It stands there combined with art. I want to make something that has more of the truth and not so much of art. Which means you have to go out on a limb—because people are more comfortable dealing with art than with the truth."

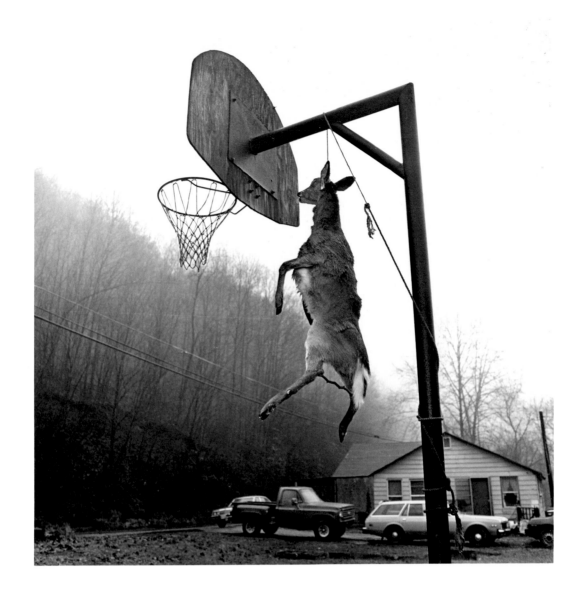

Untitled,
(Grapevine Series)
1991–95

"I take the viewpoint that reality is fascinating, but that my view of it will be hopelessly subjective
and all of this will be articulated by the photographic properties to which pictures are inevitably bound."

Picturing everyday life through a long-term study is a recurring motive in photography. When the subject is strange or different, the photographer often runs the risk of voyeurism. For Susan Lipper, the people of Grapevine Hollow, West Virginia, provided a second home for long visits made over a five-year period. She describes the "Grapevine" series as a personal journal whose truths are enmeshed with her own questions about community, family, and relationships. In the New Documentary mode, Lipper implicates herself and the viewer in a narrative telling of boredom, anger, pride, sexuality, and love set among closely observed details that make palpable a time, a place, and its season. The adult inhabitants of this hamlet wear the effects of adversity heavily; the children alone seem touched by grace. Although the embittering cost of poverty is felt, the psychological exchange between photographer and subject becomes memorable.

Susan Lipper
American, b. 1953

Untitled,
1974

William Eggleston

"Sometimes I like the idea of making a picture that does not look like a human picture. Humans make pictures which tend to be about five feet above the ground looking out horizontally. I like very fast-flying insects moving all over and I wonder what their view is from moment to moment. I have made a few pictures which show that physical viewpoint."

Clarksdale,
Mississippi,
1963

Danny Lyon

"Photographers traditionally have worked in silence, putting everything into the picture, that small area,
 measured in inches, that they have staked out. I have . . . usually presented my photographs in books with
 a text. In the texts I have spoken through other people's voices, sometimes out of respect for what they had
 to say, and sometimes as a disguise for myself."

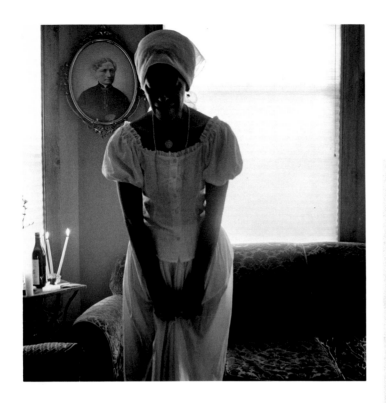

If your palm itches you gonna get some money.

If your nose itches somebody is coming to visit.

If your palm itches you gonna get some money

If your nose itches somebody is coming to visit

If your ear itches somebody you know is talking bad about you

If your foot itches somebody you know is going to die

If you leave your purse on the floor you'll never have money

If you hit your elbow you gonna see someone you love

If a person comes to your home and you sense bad karma, put out a pan of water and when the person leaves, take it outside and dump it. If somebody tries to put a jinx on you, gather up all the signs, put them in newspaper or a bag, tie a string around it and throw it in the river. The water will return the jinx to the sender. If a hag torments you, put a knife or bible under your pillow or wear red to flatter it. It's good to keep a frizzled chicken around, they're good for digging up conjure bags and other sleight-of-hand tricks, buried under your doorstep. If the bird comes clean and loses its feathers, it's proof that it scratched up on something meant for you.

"Photography can still be used to champion activism and change. . . . Perhaps what is important to consider is that our age necessarily demands, as Allan Sekula eloquently put it, 'a new documentary,' one that develops new forms, new visual possibilities. And one that still embraces a photography that is essentially humanist. . . ."

Carrie Mae Weems
American, b. 1953

Carrie Mae Weems has brought together diverse talents as an image-maker, folklorist, and poet to create a powerful narrative form that confronts issues of race, gender, and class. Often combined with spoken narratives on tape, her installations connect the viewer with the voicings of a soul seeking to understand "something that's true about us, and that truth can be awfully ugly and awfully beautiful, too." The images and texts here are part of a series through which Weems explores the Gullah culture of Georgia's Sea Islands. Descendants of slaves taken from the Gola tribe of West Africa in the seventeenth and eighteenth centuries, the Gullah have maintained much of their ancestral tradition due to geographic isolation from mainland and mainstream. Juxtaposing photographs with folk sayings and quotes from popular music (some of which are glazed onto dinner plates), Weems weaves a rich fabric that makes the past a vivid presence in "this cultural place that I happen to occupy."

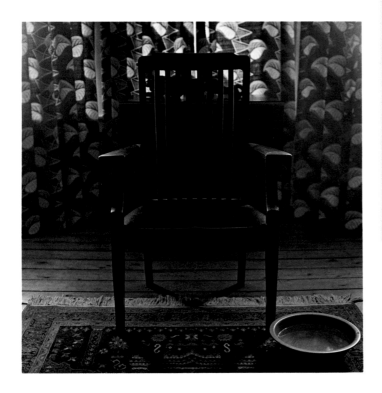

A night bird flying across your path brings bad luck unless
two sticks are placed crosswise on the ground. A rabbit
running across the path means trouble ahead.

It's bad luck to have to turn back after starting out on a trip.
But if you do, make a cross on the ground to keep away bad luck.

A rooster crowing just before midnight brings bad luck
unless the fire is stirred three times.

Untitled
(From the "Sea Islands" series),
1992

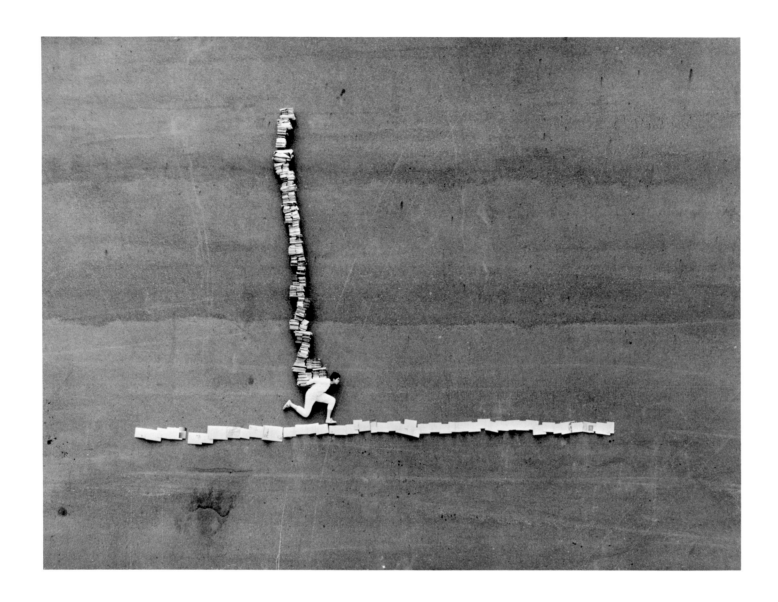

"I take only portrait photographs. Under each photograph I write a [title] to give the photograph some further dimension. I then put them together into small series so that each one, as a link in the series, is enhanced by other expressive possibilities. . . . Through my photographs, I believe I am able, precisely and frankly, to express my inner mood and feelings."

Miro Ŝvolík
Czechoslovakian, b. 1960

There I Spent the
First Years, 1986

Miro Ŝvolík came of age during periods of upheaval in his native Czechoslovakia. From the hopeful days of the Velvet Revolution through the ethnic division of the country, political instability has only served to foster in him a sense of optimism and humor. He first studied in Bratislava, where the focus was on experimentation and expressiveness which formed his taste for lyricism mingled with folk traditions and the surreal. Later, in the photography department of Prague's Academy of the Performing Arts, Ŝvolík immersed himself in creative photography and film. During the mid-1980s, his mature style emerged in a series entitled "My Life as a Man," from which the image here later evolved. These were whimsical, staged narratives, shot from a rooftop, in which his friends acted out his fictive premises. Constructed in sequences, the series (which recalls gestural silhouette illustrations in traditional Slovak folk art), is rooted in ideas about cinematic time and montage.

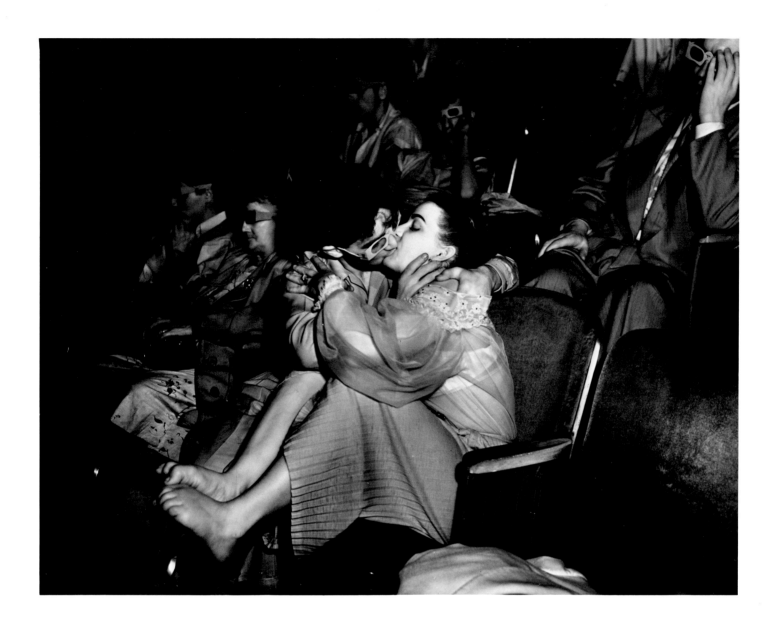

"I was on the scene; sometimes drawn there by some power I can't explain, and I caught the New Yorkers with their masks off . . . not afraid to Laugh, Cry, or make Love. What I felt I photographed, laughing and crying with them."

During a period when freelance newspaper photographers sold their pictures for about five dollars each, Arthur Fellig (Weegee) became something of an renegade in order to succeed. He had to know where the news was, so he put a police-band radio in his car; to be on the spot, he slept in his clothes. And he had an approach to picture-taking that resulted in graphic, poster-like images that, as curator John Coplans wrote, "snatch the explosive moment out of the air." The image here has the archetypal character that marks his work: shot at close range and sharply lighted by flash, using camera settings that serve to darken everything around the subject. Although Weegee moved on to work for *Life* and *Vogue*, and published his photographs in the 1945 book, *Naked City*, the fame he craved did not come until after his death. As the distinction between "taking" and "making" a photograph faded from the lexicon of creative photography, curatorial doors opened onto serious study of images by "Weegee the Famous."

Weegee (Arthur Fellig)
American, b. Austria,
1899–1968

Palace Theater,
1945

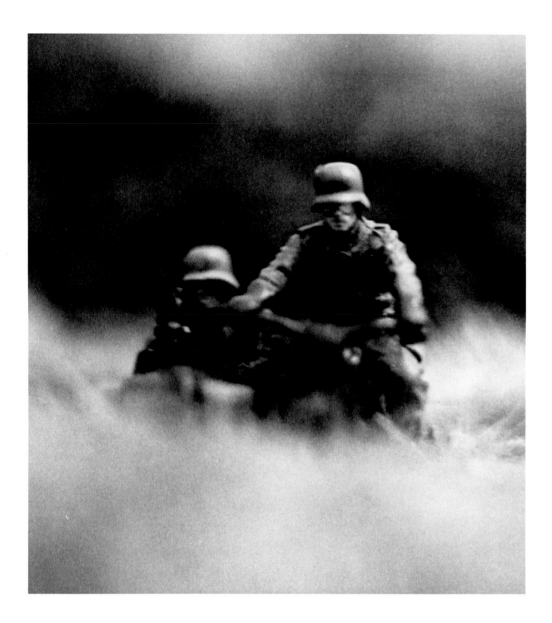

Untitled,
from the series
"Hitler Moves East,"
ca. 1976

"With a few simple objects I have been able to create a disorienting sense of authenticity. I have tried not to deceive, but rather to create a dynamic tension between our visual sense and our sense of reality; all the time asking the question of both myself and the viewer what is truly real in our world today. . . . To me a photograph is a page from life, and that being the case, it must be real."

David Levinthal
American, b. 1949

David Levinthal is among a group of photographers who create fictional tableaux using toys as surrogates for their human counterparts. Based on histories documented in films and photographs, distanced by time, events are transformed into surreal, "ready-made" realities. For the "Hitler Moves East" series, Levinthal populated miniature dioramas (built on his kitchen table) with toys reenacting the Nazi invasion of Russia during World War II. The resulting photographs were published in book form along with a text by Gary Trudeau, creator of the "Doonesbury" comic strip. With their lack of detail (which gives the impression of hastily snapped news photos) and the sepia tonality often found in archival images, these pictures lure the viewer into a spooky, ersatz truth that is tantalizing because it is so obviously made up. Levinthal's simulations also play with the increasingly blurred line separating photography's truthfulness and its role in the artist's battery of creative tools.

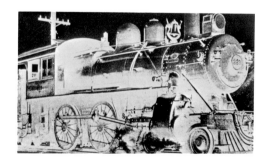

"To me, photographs are like words and I generally will place many photographs together . . . in order to construct a free-floating sentence that speaks about the world I witness."

"David Wojnarowicz has caught the age-old voice of the road, the voice of the traveler, the outcast, the thief, the whore, the same voice that was heard in Villon's Paris, in the Rome of Petronius," said the poet William S. Burroughs about Wojnarowicz's 1982 book, *Sounds in the Distance*. Yet those words also characterize the artist's approach to his photographic projects. Raised in a violently abusive family, Wojnarowicz courted danger elsewhere. Hustling in Times Square as a youngster, later hitchhiking and train-hopping through one third of his life, he photographed (with a stolen camera) the encounters that shaped an "authentic history" of the 1970s and '80s. In photographic, painted, performed, and filmed narratives overlaid with complex visual and verbal metaphor, Wojnarowicz forged a chronicle of outlaw reality for a generation that wrestled with issues of gender, identity, ethnicity, and AIDS.

David Wojnarowicz
American, 1954–1992

David Time,
1988–89

Notes

A COLLECTOR'S VIEW

1. John Elsner and Roger Cardinal, *The Cultures of Collecting*, p. 1, London: Reaktion Books, 1994.

2. Charles Darwin, *Journal of Researches into the Geology & Natural History of the Various Countries visited during the Voyage of the Beagle round the World*, p. 118, London: J. M. Dent and New York: E. P. Dutton, 1906.

3. My thanks to Jeffrey Fraenkel for the Sam Wagstaff remark.

4. *La Lumière*, 18 May 1851, p. 1. I owe this reference to Bernard Marbot, chief curator of prints and photographs at the Bibliothèque Nationale, Paris.

5. Frances Dimond and Roger Taylor, *Crown and Camera: The Royal Family and Photography 1842–1910*, Harmondsworth: Penguin Books, 1987.

6. Eugenia Parry Janis, "Seeing, Having, Knowing: A Rush for the Spoils," in *The Invention of Photography and Its Impact on Learning: Photographs from Harvard University and Radcliffe College and from the Collection of Harrison D. Horblit*, eds. Louise Todd Ambler and Melissa Banta, pp. 1–17, Cambridge, Mass: Harvard University Library, 1989.

7. The Townshend, Cole and Cameron acquisitions are described in the present writer's *Photography: An Independent Art. Photographs from the Victoria and Albert Museum, 1939–1996*, London: Victoria and Albert Museum and Princeton: Princeton University Press, 1997.

8. *The Photographic World*, vol. II, no. 14, February 1872, pp. 51–52. My thanks to Liz Siegel, University of Chicago for this reference.

9. Harry H. Lunn, Jr., "Lunn's History of Collecting Photographs," in *The Photograph Collector*, vol. XVI, no. 6, 15 June 1995, pp. 1–4. An earlier version appeared, with other important contributions, in a "Connoisseurs and Collections" issue of *Aperture* in Summer 1991.

10. Malcolm Daniel, "Photography at the Metropolitan: William M. Ivins and A. Hyatt Mayor," *History of Photography*, vol.21, no.2, Summer 1997, pp. 110–16.

11. Christine Kuhn, "'*fur solche andachtige Betrachtung gesammelt.*': Fotografie in der Kunstbibliothek," in *Kunst in der Kunstbibliothek und her Sammlungen*, ed. Bern Evers, pp. 322–33, Berlin: Kunstbibliothek, Staatliche Museen zu Berlin, Preussischer Kultur-besitz, 1994. My thanks to Peter Galassi for drawing Dr. Glaser's work to my attention.

12. Lucia Moholy, *A Hundred Years of Photography*, p. 178, Harmondsworth: Penguin Books, 1939.

13. Helmut and Alison Gernsheim, *A History of Photography*, Oxford: Oxford University Press, 1956.

14. This argument is developed in *Photography: An Independent Art*, op. cit.

15. Beth Gates-Warren, *Twenty Years of Photography at Sotheby's*, with contributions by Anne Horton, Robert Sobieszek and Paul F. Walter, New York: Sotheby's, 1995.

16. Susan M. Pearce, *On Collecting: An Investigation Into Collecting in the European Tradition*, p. 32, London and New York: Routledge, 1995. My thanks to all those who have generously provided references for this arti-cle, and especially Martin Scofield, University of Kent, Canterbury; Andrew Eskind and Rachel Stuhlman, George Eastman House, Rochester, N.Y.; Lindsey Stewart of Christie's; Philippe Garner of Sotheby's and the poet Grace Schulman, in New York City.

THE LIGHT ON THE STAIRS

1. *Reading American Photographs*. Alan Trachtenberg. Hill & Wang. 1989. P. 239.

2. *Walker Evans at Work*. Jerry L. Thompson. Thames and Hudson, London. 1994. p. 61.

THINKING ABOUT PHOTOGRAPHS

1. John Szarkowski, *Looking at Pictures, 100 Pictures from the Collection of the Museum of Modern Art* (New York: Museum of Modern Art, 1973), p. 64.

2. Beaumont Newhall, *The History of Photography from 1839 to the Present Day* (New York: Museum of Modern Art, 1949) and Helmut and Alison Gernsheim. There are two notable exceptions. Walter Benjamin's 1936 essay "The Work of Art in the Age of Mechanical Reproduction" published in Hannah Arendt ed., *Illuminations* (New York: Schocken Books, 1968) does not demonstrate a specific approach for looking at photographs. Rather, it provides a political analysis of photography, and questions the relevance of aesthetics to a medium capable of mass reproduction. Benjamin's ideas serve as the underpinning for most thinking about postmodern photography. In William M. Ivins, Jr., *Prints and Visual Communication* (Cambridge: Harvard University Press, 1953) the author views photography as a form of communication in the tradition of other graphic arts. Ivins' approach serves as a forerunner for Szarkowki's thoughts about the medium.

3. John Szarkowski, *The Photographer's Eye* (New York: Museum of Modern Art, 1966) n.p.

4. Ansel Adams with Mary Street Alinder, *Ansel Adams, An Autobiography* (Boston: Little Brown and Company, 1985), pp. 110–11.

5. For an excellent analysis of the Museum of Modern Art's influence on the understanding of contemporary photography see Christopher Phillips, "The Judgement Seat of Photography" in Richard Bolton, ed. *The Contest of Meaning, Critical Histories of Photography*. (Cambridge, Massachusetts: The MIT Press, 1989), pp. 15–48.

6. See Trudy Wilner Stack, "1927–1937, An Appetite for the Thing Itself, Vegetables and Female Nudes," published in Gilles Mora ed., *Edward Weston, Forms of Passion* (New York: Harry N. Abrams, 1995), pp. 134–41.

7. Dorothy Norman, *Alfred Stieglitz: An American Seer* (New York: Aperture, 1960), p. 144.

8. Gus Kayafas ed., *Stopping Time, The Photographs of Harold Edgerton* (New York: Harry N. Abrams, 1987), p. 18.

9. Danny Lyon, *Conversations with the Dead, Photographs of Prison Life with the Letters and Drawings of Billy McCune #122054* (New York: Holt, Rinehart and Winston, 1969), p. 8.

UNCOMMON FAMILIAR

1. Simon Watney, "Making Strange: The Shattered Mirror" published in Victor Burgin ed., *Thinking Photography* (London: Macmillan Education Ltd., 1982) p. 170.

TELLING TALES

1. Allan Sekula, "On the Invention of Photographic Meaning" in Victor Burgin, ed., *Thinking Photography* (London: Macmillan Education Ltd., 1982), p. 87.

2. William S. Johnson, ed., *W. Eugene Smith: Master of the Photographic Essay*, New York: Aperture, 1981, p. 13.

3. Alan Trachtenberg, "Lewis Hine: The World of His Art 1977" in Vicki Goldberg, ed., *Photography in Print: Writings from 1816 to the Present* (Albuquerque: University of New Mexico Press, 1981), p. 252.

4. Andrea Kirsh, "Carrie Mae Weems: Issues in Black," in Andrea Kirsh and Susan Fisher Sterling, *Carrie Mae Weems*, exh. cat. (Washington, D.C.: The National Museum of Women in the Arts, 1993), p. 11.

Credits

All photographs copyright to the artist and courtesy of the Sondra Gilman Collection unless otherwise noted. Ansel Adams: Copyright © 1997 by the Trustees of the Ansel Adams Publishing Rights Trust. All rights reserved. Robert Adams: Courtesy Fraenkel Gallery, San Francisco. Diane Arbus: Copyright © 1969 The Estate of Diane Arbus. Margaret Bourke-White: Courtesy Margaret Bourke-White Estate. Bill Brandt: Bill Brandt copyright © 1955 Bill Brandt Archive Ltd. Brassaï: Copyright © Gilberte Brassaï. Sarah Charlesworth: Courtesy Jay Gorney Modern Art. Chuck Close: Copyright © Chuck Close, courtesy PaceWildenstein-MacGill, New York. Imogen Cunningham: Copyright © The Imogen Cunningham Trust. Harold Edgerton: Copyright © Edgerton Foundation, 1997, courtesy of Palm Press, Inc. William Eggleston: Copyright © 1997 Eggleston Artistic Estate. Walker Evans: Copyright © Walker Evans Archive, The Metropolitan Museum of Art. Louis Faurer: Copyright © Louis Faurer, courtesy Howard Greenberg Gallery, New York. Robert Frank: Copyright © Robert Frank, courtesy PaceWildensteinMacGill, New York. Dan Graham: Courtesy Marian Goodman Gallery, New York. John Gutmann: Courtesy Fraenkel Gallery, San Francisco. Peter Hujar: Copyright © Estate of Peter Hujar. André Kertész: Copyright © Estate of André Kertész. William Klein: Copyright © William Klein, courtesy Howard Greenberg Gallery, New York. Jacques-Henri Lartigue: Copyright © Ministère de la Culture, France/ A.A.J.H.L. Louise Lawler: Courtesy of the artist and Metro Pictures. David Levinthal: Copyright © David Levinthal, courtesy Janet Borden, Inc. Helen Levitt: Courtesy Fraenkel Gallery, San Francisco. O. Winston Link: Courtesy the Art Museum of South Texas, Corpus Christi. Susan Lipper: Copyright © 1991 Susan Lipper. Danny Lyon: courtesy Magnum Photos. Sally Mann: Copyright © Sally Mann, courtesy Edwynn Houk Gallery. Robert Mapplethorpe: Copyright © The Estate of Robert Mapplethorpe. Ana Mendieta: Copyright © Estate of Ana Mendieta, courtesy of the Estate of Ana Mendieta and Galerie Lelong, New York. Ray K. Metzker: Courtesy Locks Gallery. Richard Misrach: Copyright © Richard Misrach, courtesy Robert Mann Gallery. Lisette Model: Copyright © Lisette Model Foundation, New York, courtesy Eleanor Barefoot Gallery, N.Y. Paul Outerbridge, Jr.: Copyright © Estate of Paul Outerbridge, Jr./G. Ray Hawkins Gallery, Santa Monica. Jack Pierson: Courtesy the artist and Luhring Augustine Gallery. Man Ray: Copyright © 1998 Man Ray Trust/Artists Rights Society, N.Y./ADAGP, Paris. Cindy Sherman: Courtesy of the artist and Metro Pictures. Laurie Simmons: Courtesy of the artist and Metro Pictures. W. Eugene Smith: Copyright © W. Eugene Smith, courtesy Black Star.

Frederick Sommer: Copyright © Frederick Sommer, courtesy PaceWildensteinMacGill, New York. Louis Stettner: Copyright © Louis Stettner, courtesy Bonni Benrubi Gallery, N.Y. Paul Strand: Copyright © Aperture Foundation, Inc. Hiroshi Sugimoto: Copyright © Hiroshi Sugimoto. Miro Švolík: Copyright © Miro Švolík, courtesy Stuart Levy Fine Art. Weegee: Weegee (Arthur Fellig) copyright © 1994, International Center of Photography, New York, Bequest of Wilma Wilcox. Carrie Mae Weems: Courtesy PPOW Gallery, New York. William Wegman: Copyright © William Wegman, courtesy PaceWildensteinMacGill, New York. Edward Weston: Copyright © 1981 Center for Creative Photography, Arizona Board of Regents. Minor White: Copyright © 1982 by The Trustees of Princeton University, courtesy The Minor White Archive, Princeton University. Garry Winogrand: Courtesy Fraenkel Gallery, San Francisco, and copyright © the Estate of Garry Winogrand. David Wojnarowicz: Courtesy PPOW Gallery, New York. Francesca Woodman: Courtesy of Betty and George Woodman. Piet Zwart: Courtesy of Doctor P. Zwart.

When I Buy Pictures

by Marianne Moore

or what is closer to the truth,
when I look at that of which I may regard myself as the
 imaginary possessor,
I fix upon what would give me pleasure in my average moments:
the satire upon curiosity in which no more is discernable
than the intensity of the mood;
or quite the opposite—the old thing, the medieval decorated
 hatbox,
in which there are hounds with waists diminishing like the
 waist of the hourglass,
and deer and birds and seated people;
it may be no more than a square of parquetry; the literal
 biography perhaps,
in letters standing well apart upon a parchment-like expanse;
an artichoke in six varieties of blue; the snipe-legged
 hieroglyphic in three parts;
the silver fence protecting Adam's grave, or Michael taking
 Adam by the wrist.
Too stern an intellectual emphasis upon this quality or that
 detracts from one's enjoyment.
It must not wish to disarm anything; nor may the appoved
 triumph easily be honored—
that which is great because something else is small.
It comes to this: of whatever sort this is,
it must be "lit with piercing glances into the life of things";
it must acknowledge the spiritual forces which have made it.